IMAGES
of America

BUENA PARK

To my wife, Gail, for the history we discovered, lived, and make together in Buena Park, the community, and the book.

IMAGES
of America

BUENA PARK

Dean O. Dixon

ARCADIA

Published by Arcadia Publishing
Charleston SC, Chicago IL, Portsmouth NH, San Francisco CA

Printed in Great Britain

Library of Congress Catalog Card Number: 2004111494

For all general information contact Arcadia Publishing at:
Telephone 843-853-2070
Fax 843-853-0044
E-mail sales@arcadiapublishing.com
For customer service and orders:
Toll-Free 1-888-313-2665

Visit us on the internet at http://www.arcadiapublishing.com

CONTENTS

ACKNOWLEDGMENTS

The owner of every photograph in this book is identified at the end of each caption. They made this book possible and deserve the most credit with my sincere gratitude. Since most pictures came from the Buena Park Historical Society, I expressly thank their board of trustees, officers, and curator, Jane Mueller.

 If you have more information and photographs, please consider providing them to the Buena Park Historical Society. This all-volunteer organization of interested citizens depends on your help. If you want more information, I recommend the Buena Park Historical Society website at www.historicalsociety.org.

—Dean O. Dixon

INTRODUCTION

Disparate images whirled through my mind when I first contemplated the historical diversity of Buena Park as a book of photographs. I had written histories before, using pictures to illustrate the text, but reversing that process was daunting for me.

The story of Buena Park itself begins with a wholesale grocer from Chicago, who founded the town during the 1880s land boom precipitated by the railroad's initial arrival in southern Los Angeles County. This area did not become Orange County until 1889.

Intent on cattle ranching, James A. Whitaker bought 690 acres of former Rancho Los Coyotes land from Abel Stearns. However, Whitaker was persuaded to found a town in 1887 when Santa Fe Railroad land agent George Fullerton offered to build a depot there.

Fullerton reneged and put the SFRR depot in the next town east (subsequently named for him) so Whitaker responded by moving his buildings and Buena Park one mile south. There the Southern Pacific Railroad laid tracks and constructed the depot that Whitaker needed. Buena Park prospered unlike "paper towns" that failed in the planning stages, e.g. Centralia and Savanna.

Whitaker opened a general merchandise store, helped found a church, and began cultivating economic development just as his brother and neighbors began cultivating the relatively shallow topsoil using artesian well water. Over the years, cash crops included grapes, nuts, sugar beets, beans, some citrus, and, of course, many different berries.

In 1889 Whitaker got the Pacific Creamery Company, which canned condensed milk under the Lily Cream label, to build a factory in Buena Park. This was the first industry established in Orange County. The resulting demand for raw milk and labor supported a robust local economy so that Buena Park's population grew to 995 people by 1900.

World events, such as World War I, the Depression, and World War II, certainly had an impact on Buena Park. But during these historic periods, Buena Park also had an impact on the world. The multi-vitamin, a wide variety of hybrid crops, network marketing, and the theme park were all invented in Buena Park.

In 1954 the Santa Ana Freeway excavated a canyon-sized trench that cut the heart out of the business district. Downtown Buena Park was gone. But the freeways also brought suburban development that led to the building of the Buena Park Regional Shopping Center in 1960. Later called the Buena Park Mall, it was enclosed in 1980 and renovated in 2003 when it was renamed Buena Park Downtown.

The City of Buena Park was incorporated in 1953 to deal with residential services and safety issues. The 1950 population of 5,483 exploded to 46,601 by 1960. During its first 60 years,

Buena Park had barely reached small-town status, but during the next 10 years it grew almost 9 times larger. In the year 2000, the population was 78,282.

The rapid growth of Buena Park was not unique, but the outcome was. While neighboring communities grew into suburbs, Buena Park grew into a city. From its very founding, Buena Park sought a balance of residential, commercial, and industrial development for a stable yet dynamic local economy. Standing the test of time, these objectives guide planning to this day. In this volume, my intent is less to inform in a complete or chronological way than to present the essence of Buena Park's heritage. Most of the topics touched on above will be expanded through related photographs and captions with more details.

I trust the whirl of images throughout this book will provide you with a feel for the evolution of Buena Park. Whether you live here, vacation here, or never get closer than these pages, it is my sincere hope that you enjoy Buena Park.

—Dean O. Dixon
July 2004

One

LA PLAZA BUENA

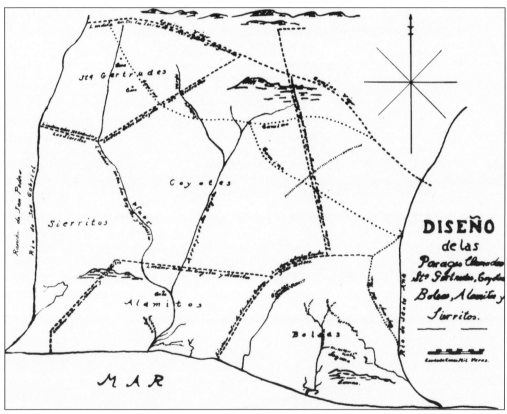

In 1784 the governor of California petitioned the king of Spain to grant 300,000 acres of land to José Manuel Perez Nieto. This map shows how Rancho Los Nietos was subdivided among Nieto's heirs in 1834. His eldest son, Juan José Nieto, got the 28,027-acre Rancho Los Alamitos and the 48,806-acre Rancho Los Coyotes, which included the site of Buena Park. Juan José Nieto sold Rancho Los Alamitos in 1837 and lived on Rancho Los Coyotes. (Buena Park Historical Society.)

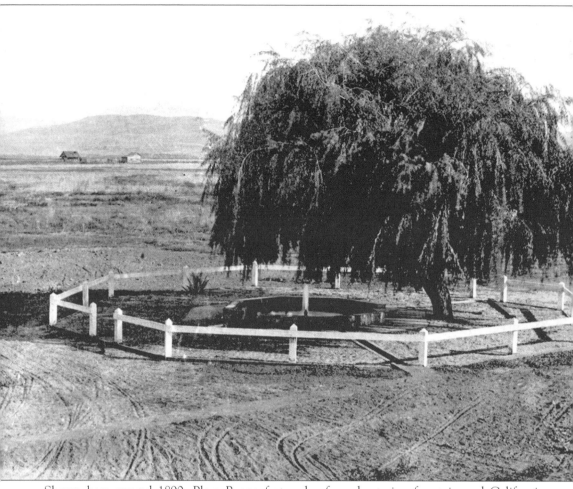

Shown here around 1890, Plaza Buena featured a fenced artesian fountain and California peppertree. A romantic version of its origin claims that Spanish missionaries used this oasis, although this seems unlikely as El Camino Real was miles east. A more likely story says peons spent the night here as they traveled back and forth to Los Angeles to sell produce harvested from river-irrigated fields on Rancho Cañon de Santa Ana owned by Bernardo Antonio Yorba. Either way, it seems the name Buena Park was derived from *plaza buena*, meaning "good or nice park" in Spanish. Plaza Buena was located near the present-day intersection of Artesia Boulevard and Beach Boulevard. (Buena Park Historical Society.)

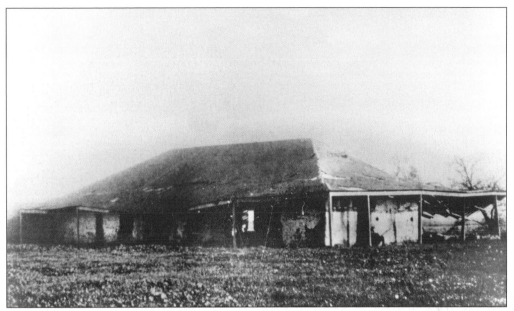

This last-known photograph of the adobe hacienda of Rancho Los Coyotes is presumed taken in the early 1940s. At that time the building already was completely open to the elements with a collapsed roof. The last remnants of the mud walls were washed away before the area was developed into the Los Coyotes Country Club in 1957. (Buena Park Historical Society.)

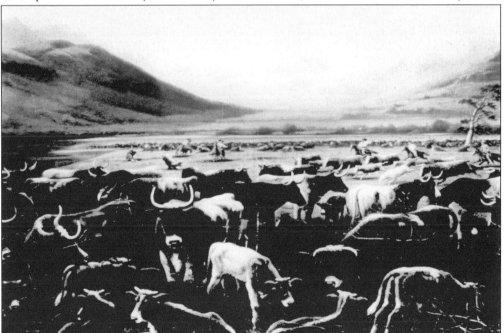

This unattributed painting shows cattle grazing on Rancho Los Coyotes. Although not depicted, the rancho headquarters was on the southern slopes of Coyote Hills, visible in the background. Comm. Robert Field Stockton's army rested there on January 7, 1847, the night before fighting the last armed conflict as the United States took control of Alta California. (Buena Park Historical Society.)

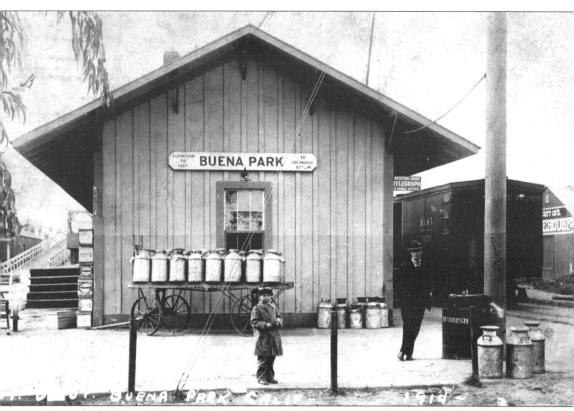

From the beginning, Buena Park's survival and success centered around the Southern Pacific Railroad Depot. Shown here in 1914, milk cans await shipment to Los Angeles while warehouses can be seen on adjacent spurs. From the ramps on the left, wagons dropped off loads of sugar beets into rail cars waiting below. (Buena Park Historical Society.)

James A. Whitaker, the founder of Buena Park, intended to become a cattle rancher when he bought 690 acres of land from Abel Stearns. However, railroads were laying tracks into what was then southern Los Angeles County for the first time. The resulting land boom of the 1880s provided more financial opportunity so Whitaker founded a town instead. (Buena Park Historical Society.)

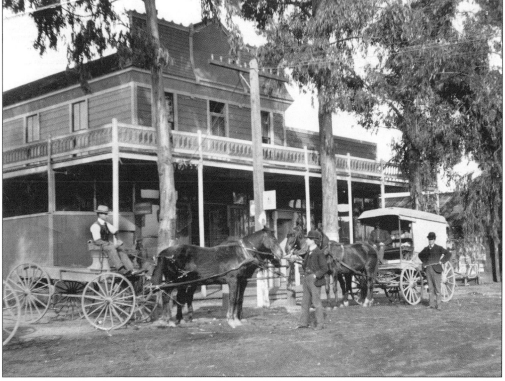

This is the earliest known photograph of the Whitaker General Store, owned and operated by Buena Park founder James A. Whitaker. Although this picture is undated, subsequent photos do not show the wrap-around balcony; buildings erected later seemingly used the wall on the left as a common wall. (Buena Park Historical Society.)

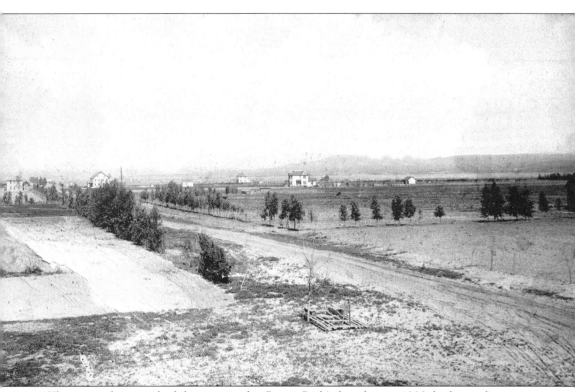

This view, photographed three years after Buena Park's founding in 1890, looks northeast across Grand Avenue at Orangethorpe. Visible in the distance, from left to right, are the Stage-Stop Hotel, the Southern Pacific Railroad Depot, the "Lily Creamery," an unidentified building, the Whitaker-Jaynes House (original location), and the home of George Wilcox, creamery engineer. Today, Wilcox's six acres are the site of the civic center. The John Wright home (extreme right) hosted the first meeting of the Buena Park Woman's Club in 1889. (Buena Park Historical Society.)

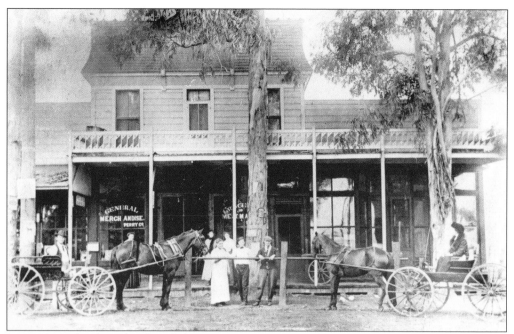

James A. Whitaker also founded Buena Park's first business, the Whitaker General Store. When he sold it to his nephew J. Harry Whitaker and partner T.A. Deering, a corner of the renamed Whitaker & Company was used as Buena Park's first post office, with J. Harry Whitaker as the first postmaster. By the time this photo was taken in 1911, Perry & Company owned the store. (Buena Park Historical Society.)

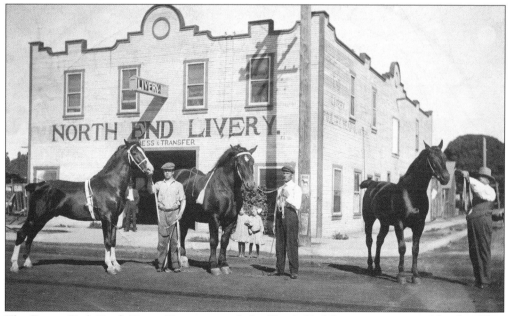

The Buena Park Draft Horse Company and the North End Livery were owned by the Glass family, who lived on a ranch near the southeast corner of Dale Street and La Palma Avenue. Before steam-powered and gasoline-powered tractors and trucks, draft horses were extremely valuable and vital to the operation of farms and ranches. (Buena Park Historical Society.)

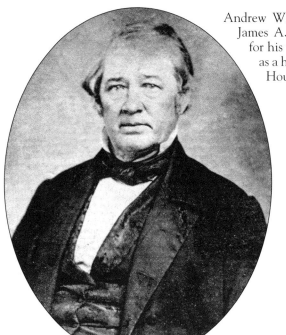

Andrew Whitaker, brother of Buena Park founder James A. Whitaker, is perhaps best remembered for his family's home, which has been preserved as a house museum called the Whitaker-Jaynes House. (Buena Park Historical Society.)

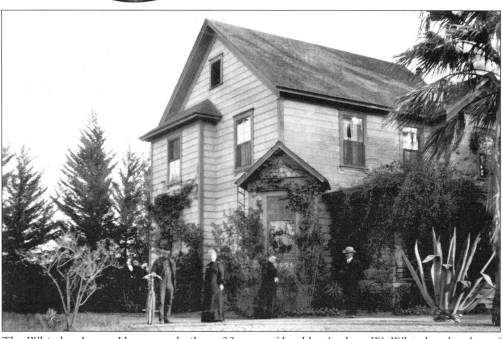

The Whitaker-Jaynes House was built on 20 acres of land by Andrew W. Whitaker, brother of Buena Park founder James A. Whitaker, in 1887. When Andrew died in 1903, his widow sold the property to Isaac DeLoit Jaynes and his wife, Edna Easterday Jaynes, who raised six children and one grandchild there. The property was acquired in 1965 by the City of Buena Park and became the home museum of the Buena Park Historical Society in 1968. (Buena Park Historical Society.)

A Civil War veteran, Dr. David William Hasson opened the first medical practice in Buena Park in 1898. Hasson served as clerk on the very first board of trustees of the Buena Park School District and was justice of peace of Buena Park Township from 1907 to 1915. He also was elected to the California Assembly in 1909. In 1905, Mrs. Hasson donated her own books to establish a lending library that became the Buena Park Library. (Buena Park Historical Society.)

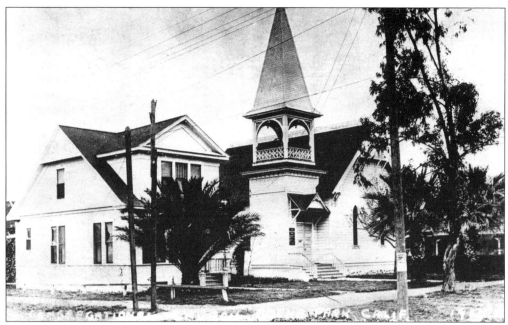

The First Congregational Church of Buena Park was founded and met in the upstairs room over the Whitaker General Store. Later, James A. Whitaker donated a "100 foot square" of land and seed money to build the first structure. Dedicated in 1891, it is pictured here in 1911 after the parsonage had been built next door. (Buena Park Historical Society.)

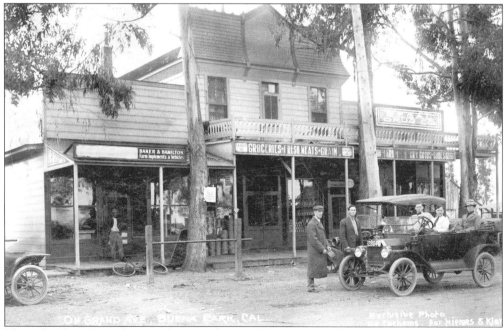

The Whitaker General Store also served as a gathering spot when few other buildings existed in Buena Park. The room above the store was the site of many historic community meetings, including the founding of the First Congregational Church of Buena Park. Original church records are in Whitaker's handwriting. (Buena Park Historical Society.)

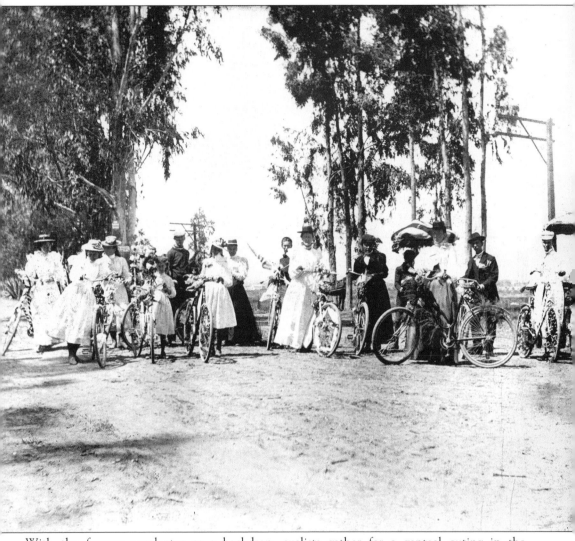

With the famous eucalyptus as a backdrop, cyclists gather for a genteel outing in the countryside. In 1891 Arni Nelson moved his family to Buena Park and set up a bicycle shop that evolved into Buena Park Lumber & Hardware Company. Located next to the Lily Creamery, this landmark was family owned and operated for over 100 years. (Buena Park Historical Society.)

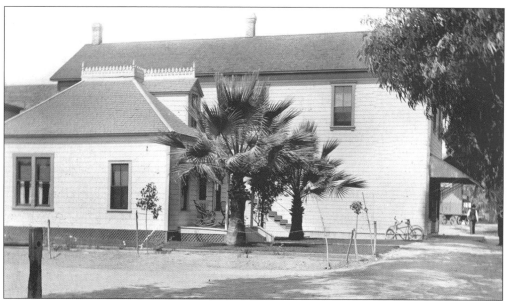

In 1900 George Warren built a general store directly across Grand Avenue from the Lily Creamery. The Southern Pacific Railroad Depot was just north of Warren's store. Warren built the family home next door to the south, on the corner at Ninth Street. Shown here in 1901, the house and store enjoyed electricity, which had come to Buena Park in 1898. (Buena Park Historical Society.)

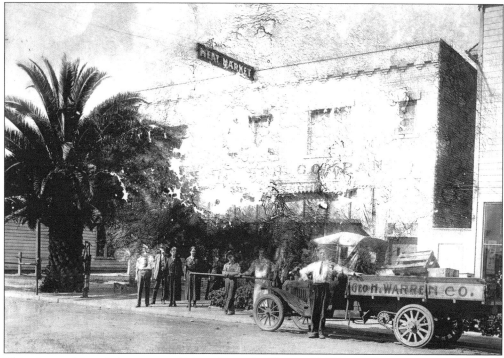

This photo, although in poor condition, shows the George H. Warren Company store and truck around 1910. Perhaps most noteworthy is the fact that the hitching posts in front of the employees were still used regularly by the store's patrons. (Buena Park Historical Society.)

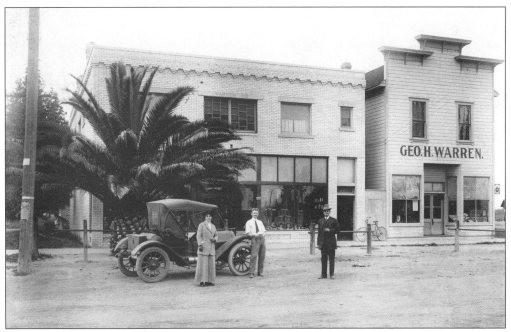

George H. Warren's first car seems to stand alone on Grand Avenue in front of his general mercantile store, the second to open in Buena Park. Warren is on the right; his wife, Emily, is on the left, and their son, Henry, is in the center leaning on the fender. The block of buildings that survives today at this location is still called the Warren Block. (Buena Park Historical Society.)

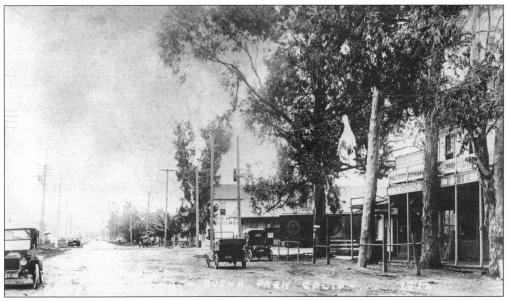

This 1912 picture looks south on Grand Avenue past the Whitaker General Store on the right. A railroad car on a spur serving the Southern Pacific Railroad Depot is barely visible just behind. Without this depot and its links to commerce, Buena Park either would have never come into being—like so many "paper towns" of the 1880s—or it would have failed. (Buena Park Historical Society.)

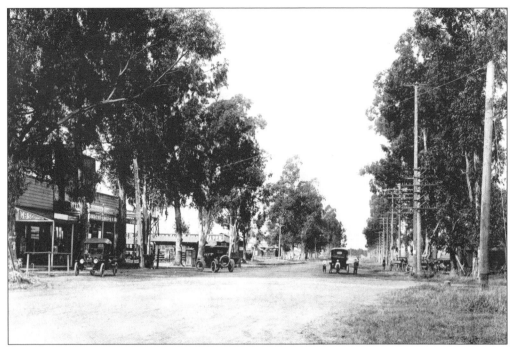

This view looks north on Grand Avenue from the Southern Pacific Railroad tracks in 1914. At the time of the town's founding, Buena Park's Grand Avenue was the widest street—at 108 feet—in the State of California. The eucalyptus trees grew into a signature part of the Grand Avenue landscape and emphasize here that it was in fact a "grand avenue." (Buena Park Historical Society.)

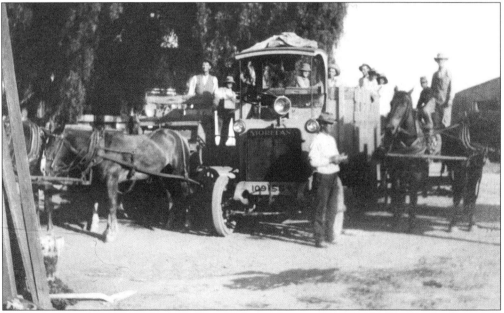

In this 1913 view local produce, arriving by horse-drawn wagons, is loaded on the Moreland truck owned by George O. Trapp to be driven to market in Los Angeles. Trapp calculates drayage as he stands at the front of the truck. (Buena Park Historical Society.)

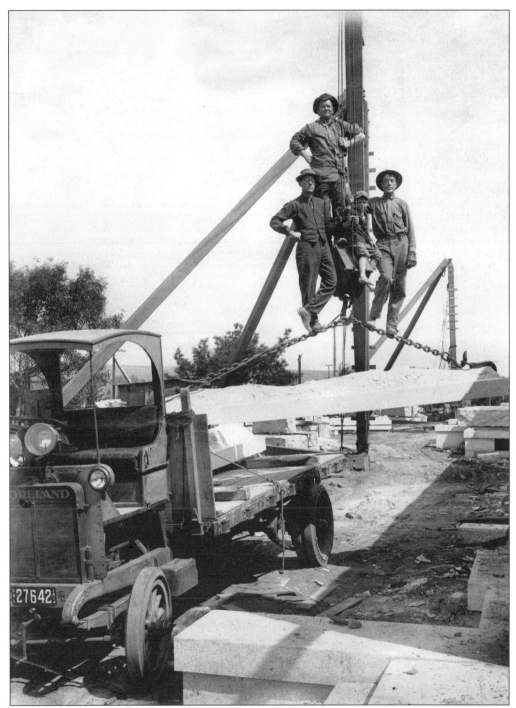

This photograph, taken in 1914, shows the strength and versatility of George Trapp's truck as it is loaded with architectural stone via tripod crane. Trapp and his wife, Violet, built their farmhouse on Olive Road (now Crescent Avenue) in 1909. While still a single-family dwelling today, it is surrounded by 1960s tract homes, not a farm. (Buena Park Historical Society.)

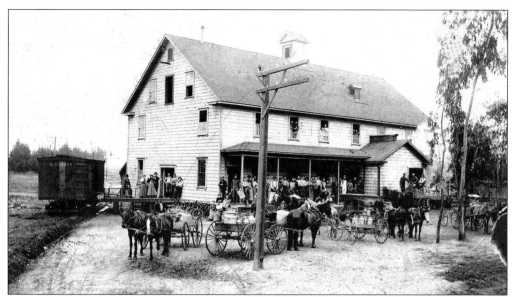

Built in 1889, the Pacific Creamery Company canned condensed milk (evaporated milk) under the Lily Cream label. This was the first industry other than agriculture in Buena Park and Orange County. Shown here in 1903, the Lily Creamery sustained the local economy with payroll and milk checks totaling $15,000 per month ($312,500 in 2003 dollars). (Buena Park Historical Society.)

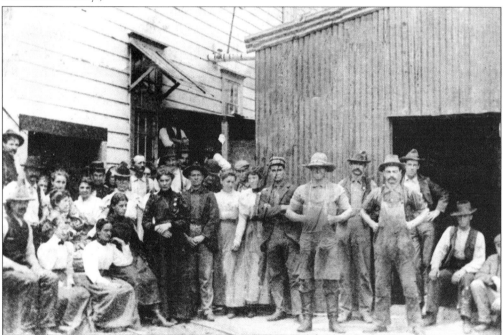

These employees of the Pacific Creamery Company were photographed in 1898, when employment was at its peak. Founded by businessmen from Nova Scotia, the company was sold to a local group after the plant was built in Buena Park. Closed in 1907, the equipment was sold to a company in Arizona where "Lily" brand dairy products are still sold. (Buena Park Historical Society.)

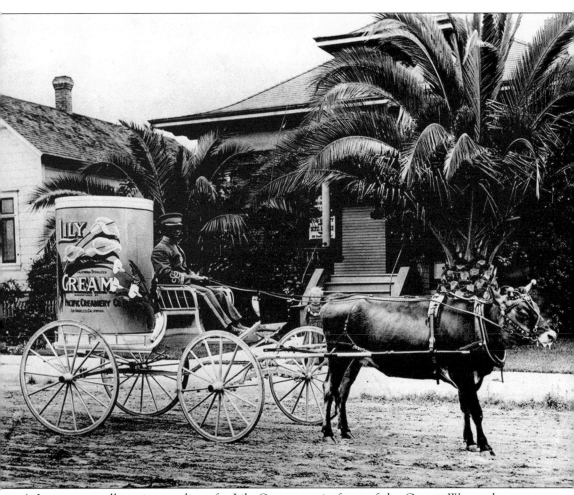

A Jersey cow pulls a giant replica of a Lily Cream can in front of the George Warren home around Ninth Street and Grand Avenue, c. 1905. This rig advertised the brand at many large gatherings, including parades and state fairs. The federal government forced the Pacific Creamery Company to change their labeling from "Lily Cream" to "Lily Milk" because the product was actually condensed/evaporated milk. (Buena Park Historical Society.)

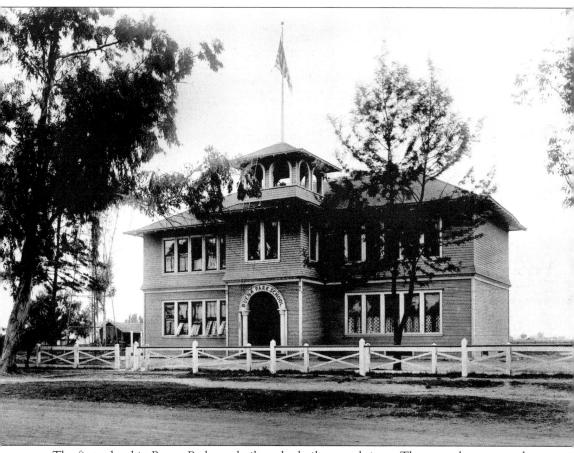

The first school in Buena Park was built and rebuilt several times. The second structure, shown here in 1909, was still called Buena Park School. Later structures were named Grand Avenue School and J.B. Sullivan School. When the latter was finally closed in the 1980s, the school grounds were developed into a housing tract. (Buena Park Historical Society.)

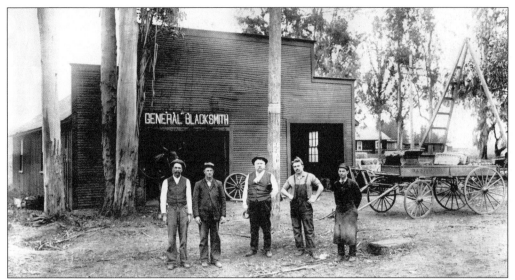

When Buena Park was founded in 1887, the local blacksmith was an integral part of modern life and especially valuable in such a rural area. Oscar West, fourth from the left in this early photo, operated his General Blacksmith shop in Buena Park, where customers could get a horse shod, a wagon fixed, and a saw sharpened. (Buena Park Historical Society.)

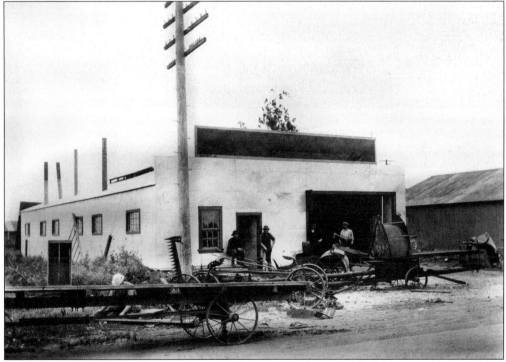

By the time this photo was taken, Oscar West General Blacksmithing Company had updated the original Victorian facade by using the formerly stylish architectural upper section as a sign. Also, smokestacks indicate the company's growth to four forges. But perhaps the most telling sign of success is the proliferation of farm equipment awaiting repair out front. (Buena Park Historical Society.)

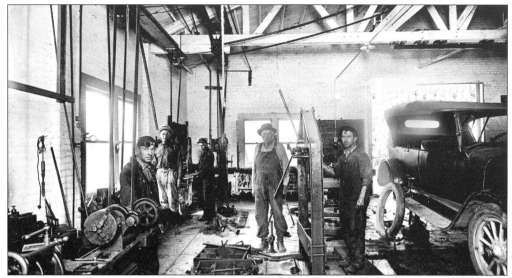

By the 1920s the Mitchell Brothers' Garage reflected a multi-faceted business that was keeping pace with the times. While the automobile had already become a mainstay of society, farm-machinery repairs remained a big part of the Mitchells' business in a country town like Buena Park. The business operates today as a machine shop. (Buena Park Historical Society.)

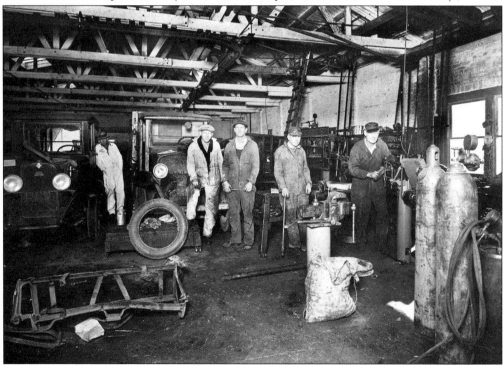

Working conditions aside, the Mitchell Brothers' Garage in the 1920s reflects changes underway throughout American society. The automobile's influence on Buena Park would prove incalculable; middle-class tourism, the Santa Ana Freeway, and suburban development were but a few unforeseen developments wrought by the automobile that forever changed Buena Park. (Buena Park Historical Society.)

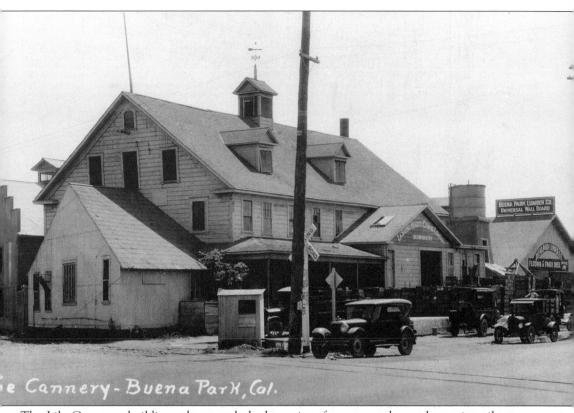

e Cannery - Buena Park, Col.

The Lily Creamery building subsequently had a series of owners and uses due to its rail-spur access to the main tracks of the Southern Pacific Railroad. Shown here as part of the La Sierra Heights Canning Company Inc., the building housed vegetable canning operations until taken by eminent domain in 1955 for ongoing construction of the Santa Ana Freeway. (Buena Park Historical Society.)

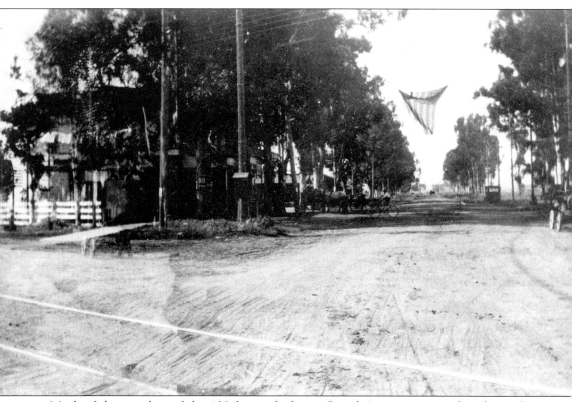

Much of the grandeur of the 108-foot-wide future Grand Avenue was attributed to it being lined by eucalyptus trees. However, the signature eucalyptus had practical origins in the barren, arid area: since there was little or no firewood available at the time, groves of eucalyptus were planted just for that purpose. (Buena Park Historical Society.)

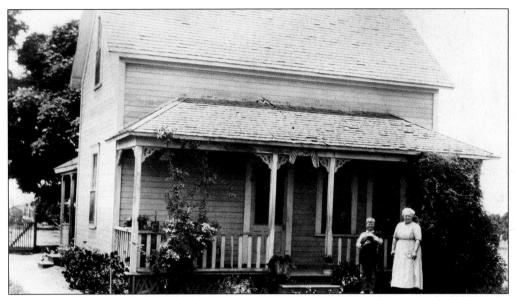

The Byron Winters house on Magnolia Avenue would be in modern-day Anaheim. However, such distinctions were less relevant when the entire area was under cultivation as farmland. Because mail came to the post office closest to the dwelling, when the Winters family went to town to claim their mail, they went to Buena Park. (Buena Park Historical Society.)

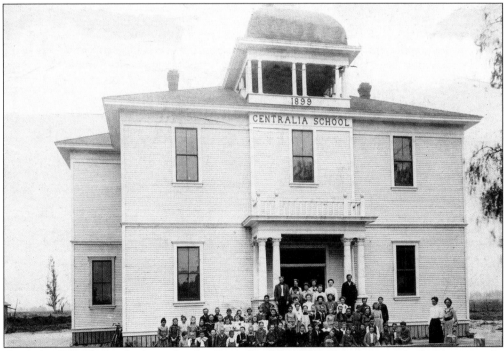

Centralia School was the basis for the Centralia School District and was the last vestige of a town named Centralia that was never built. During the land boom of the 1880s, many towns were registered; those that did not get beyond the planning stages were dubbed "paper towns." As Buena Park grew to encompass these areas, schools were named accordingly. (Buena Park Historical Society.)

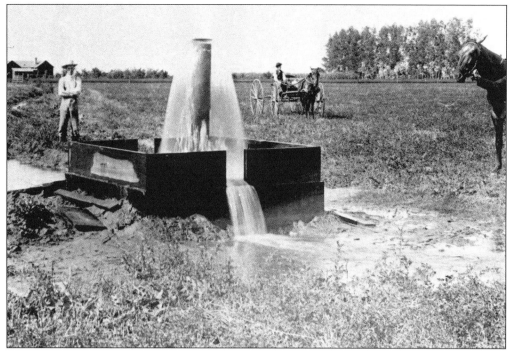

Dug deep and narrow to secure enough internal pressure to cause water to flow up and out, artesian wells brought the lifeblood of existence to this arid region. The availability of water was to have recurring consequences in local history but initially there would have been no Buena Park or Rancho Los Coyotes without the artesian well. (Buena Park Historical Society.)

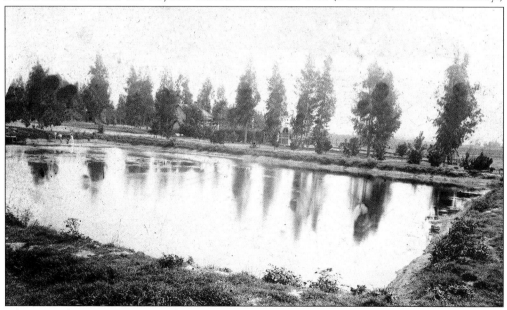

John M. Robertson was among the first to seek creative solutions to the lack of water in Buena Park. Here on the Robertson Ranch off Hansen Road (now Knott Avenue) an irrigation reservoir collected "runoff" water from the constant flow of artesian wells in the late 1890s. (Buena Park Historical Society.)

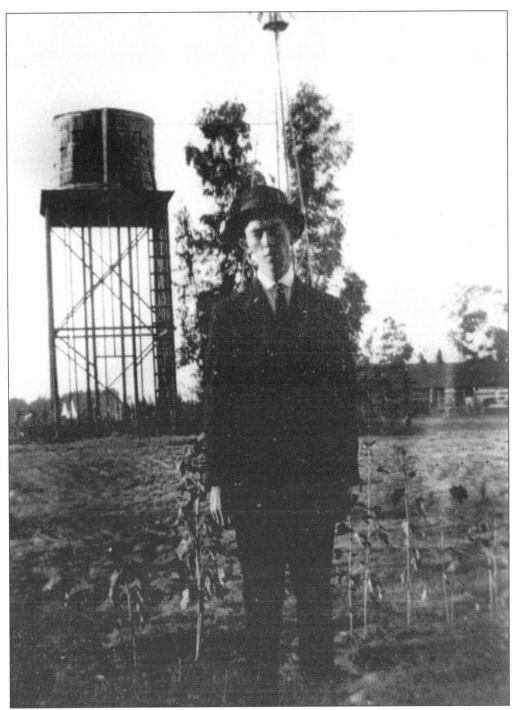

From the days of the Spanish land grant to the present, water has been critical to the development of Buena Park. When John M. Robertson bought his land on Hansen Road (now Knott Avenue) in 1890 it had artesian wells that flowed steadily. By the early 1900s, when this photo was taken, Robertson needed a new well and a windmill to pump water into a holding tank. (Buena Park Historical Society.)

Two

A COUNTRY TOWN

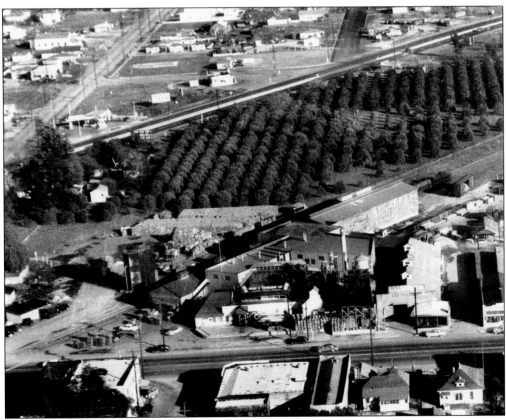

Shown here in December 1951, the original Lily Creamery site (lower center.) had become a complex owned and operated by Uddo & Taormina Company, which canned tomatoes under the brand name Progresso. Between the Southern Pacific Railroad and Manchester Boulevard was a grove owned by I.D. Jaynes. His home, which is now called the Whitaker-Jaynes House, is obscured from view by large redwood trees (left center). (Buena Park Historical Society.)

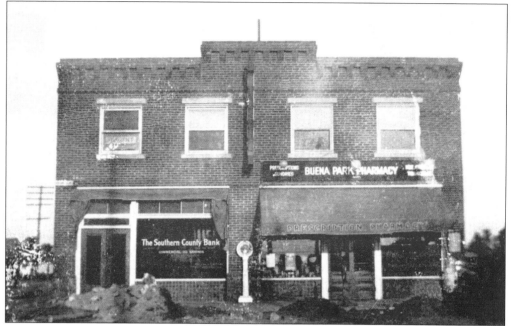

I.D. Jaynes built this structure northwest of the Southern Pacific Railroad crossing on Grand Avenue in 1917. This became the cornerstone of what was to be known as the Jaynes Block, which included the first bank in Buena Park, the Southern County Bank. Buena Park's first hospital operated on the second floor above the Buena Park Pharmacy. (Buena Park Historical Society.)

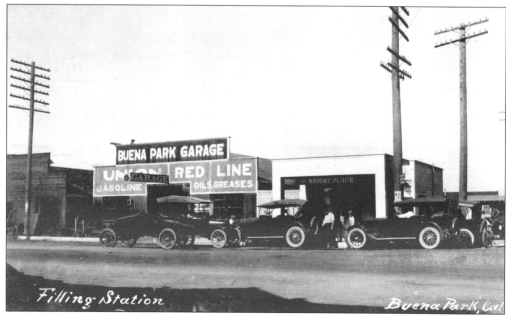

Fueling the wheels of progress, automobiles made their way to Buena Park. This 1919 photograph may have portended the problems to come, but clearly the vehicles shown here were not as concerned with right of way, traffic laws, and congestion as we are today. (Buena Park Historical Society.)

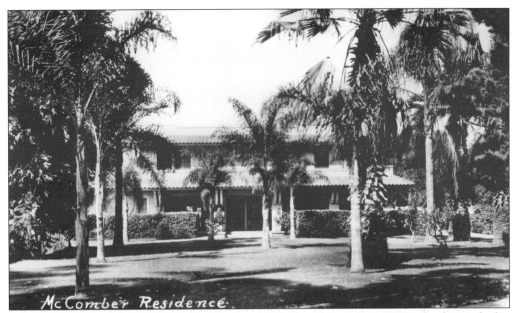

Charles L. McComber purchased the square-mile Edgebrook Ranch in 1899 in exchange for his equity in the California Hotel in Los Angeles. In uptown Buena Park, a hotel located at Grand Avenue (now Beach Boulevard) and Second Street (now Artesia Boulevard) was moved to a knoll on Edgebrook Ranch to be the family home. The home shown here in 1920 was built at the same location. (Buena Park Historical Society.)

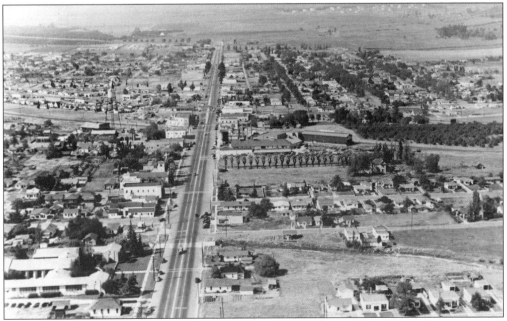

Undated but presumed to be from the 1950s, this photo looking north up Grand Avenue (now Beach Boulevard) shows, on the right side of the street at center, the cannery on the Lily Creamery site. The row of palm trees line a drive on property now occupied by city hall. The tank farm on Coyotes Hills (distant right) has had oil derricks since 1896. (Buena Park Historical Society.)

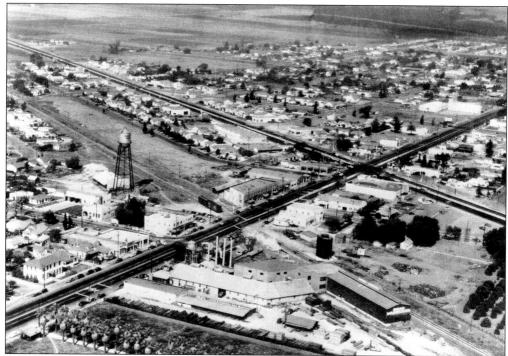

This *c.* 1945 northwest view across downtown Buena Park shows Grand Avenue (now Beach Boulevard) from lower left to upper right. The Southern Pacific Railroad (upper left to lower right) parallels Manchester Boulevard (farther right). The area in between was excavated for the Santa Ana Freeway, which removed downtown. Buena Park Lumber & Hardware is shown in the foreground alongside the expansive cannery that enveloped the site of the Lily Creamery. (Buena Park Historical Society.)

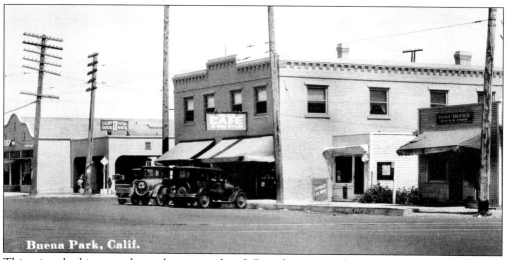

This view looking north at the east side of Grand Avenue shows, from left to right, the Chevrolet dealership, Calpet gas station, Southern County Bank (the first bank in Buena Park), Jack's Café, Sanitary Laundry, Buena Park Post Office, and tracks of the Southern Pacific Railroad (foreground). I.D. Jaynes constructed the two-story building in 1917. (Buena Park Historical Society.)

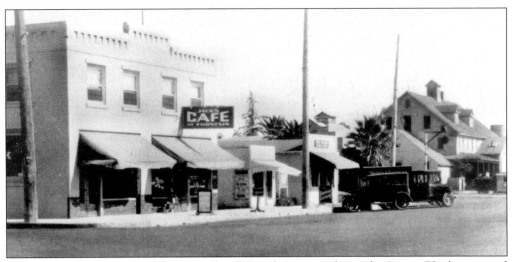

This view, looking south at the east side of Grand Avenue, shows the Jaynes Block separated from the cannery (far right) by the railroad tracks. The buildings behind the frontage structure (originally the Lily Creamery) were added to facilitate the cannery's increasing operations. (Buena Park Historical Society.)

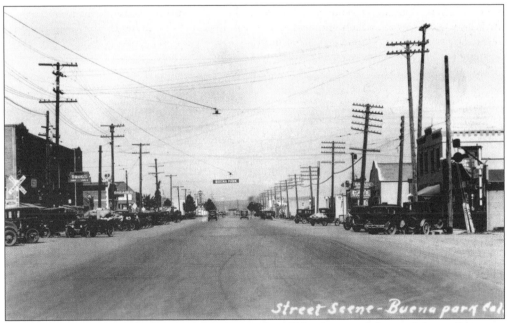

In this view looking north on Grand Avenue in the 1920s, the paved thoroughfare still appears quite grand in width although the eucalyptus trees have given way to a forest of utility poles. The ever-present Southern Pacific Railroad crossing is barely distinguishable in the foreground; this entire area was dug up and hauled away when the Santa Ana Freeway was built below grade in 1954. (Buena Park Historical Society.)

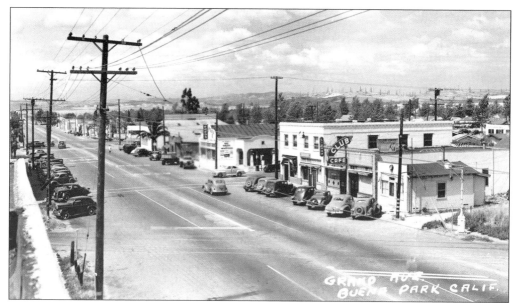

This photo of downtown Buena Park looking north on Grand Avenue (now Beach Boulevard) from the Southern Pacific Railroad tracks clearly shows the Coyote Hills in the right background where the hacienda of Rancho Los Coyotes was located. The oil derricks across those hilltops have marred the landscape since the discovery of oil in 1896. (Buena Park Historical Society.)

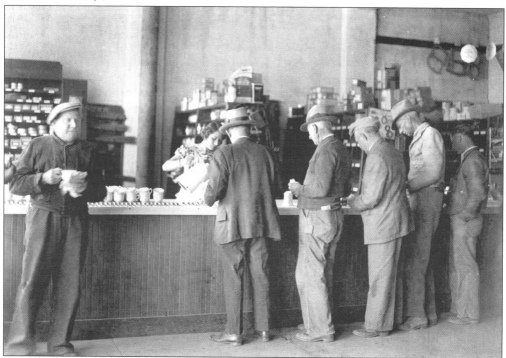

Taken at the Mitchell Brothers' Garage during the Great Depression of the 1930s, this photo shows free coffee being offered at the parts counter—at once a refreshing respite, generous gesture, and sad commentary. (Buena Park Historical Society.)

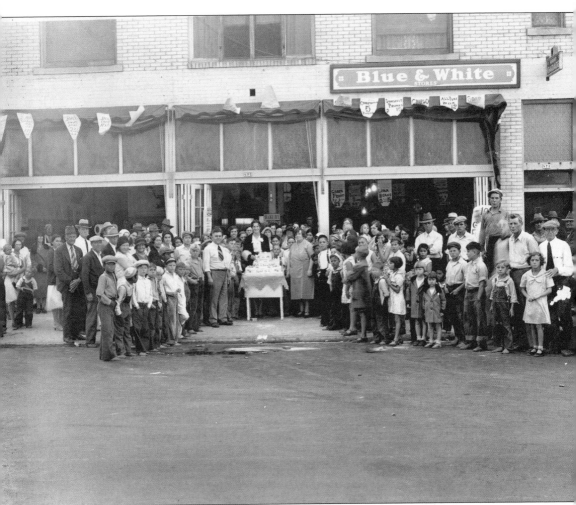

Cannon's Blue & White grocery store celebrates its opening during the Depression. Edith Beatty Page was about to cut a three-layer cake decorated "Cannon's / Faith in Buena Park / Market No 2." Located at 875 Grand Avenue, this building would be removed for the construction of the Santa Ana Freeway in 1954. (Buena Park Historical Society.)

The first meeting of the Buena Park Woman's Club was held on March 9, 1889 at Mrs. John Wright's home, shown here in 1963 before being razed. At their first meeting these Victorian ladies did some sewing for "a family which suffered fire." Ever since, the Buena Park Woman's Club has been dedicated to helping others. (Buena Park Historical Society.)

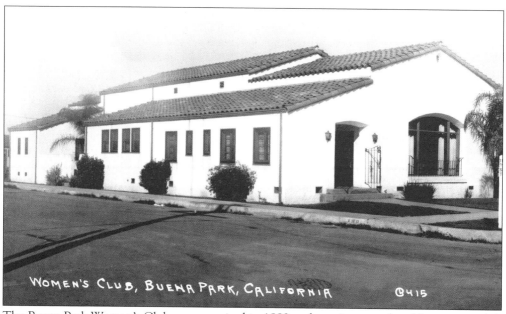

WOMEN'S CLUB, BUENA PARK, CALIFORNIA C415

The Buena Park Woman's Club was organized in 1889 and continues as the oldest service club in Buena Park. In 1919 it federated with the General Federation of Women's Clubs and the California Federation of Women's Club. BPWC accomplishments include Buena Park's first street lights, first library, and first public park. In 1931 a new building was constructed in place of the old one. This 1940 photo shows the club's "new" building, looking much as it does today. (Buena Park Historical Society.)

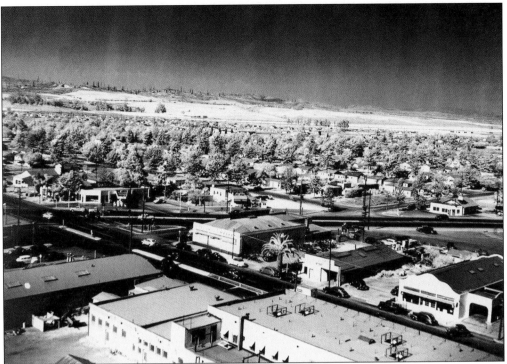

The lighting in this 1940s photograph emphasizes the oil derricks on Coyotes Hills. In the foreground, Manchester Boulevard runs horizontally as it crosses Grand Avenue (now Beach Boulevard). Newer residential developments approaching the base of Coyotes Hills are noticeable for their lack of mature trees. (Buena Park Historical Society.)

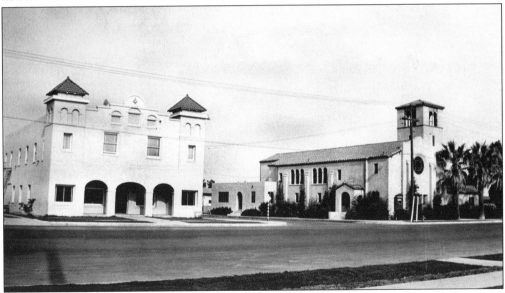

On the right in this 1932 photo is the "new" building of the First Congregational Church of Buena Park, which was rebuilt in 1929 on the site of the 1891 structure. The church looks much the same today. However, the Masonic Temple on the left was razed as were several subsequent commercial buildings. Today the site is a strip mall. (Buena Park Historical Society.)

Before its relocation in the 1940s, Godding's variety store was typical in offering aisles of goods in the then-modern self-help manner. This helped popularize variety stores and made them distinct from old general stores or even department stores. (Buena Park Historical Society.)

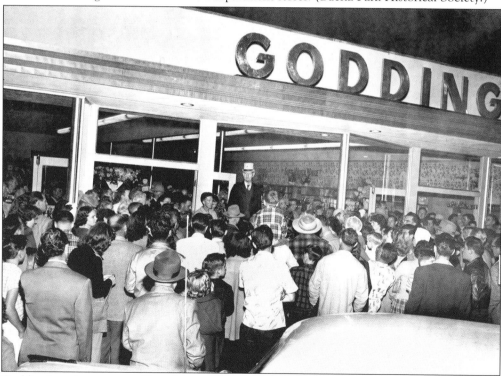

Godding's variety store on Grand Avenue around Fourth Street opened in the 1940s. Whether called the "5¢ & 10¢ store," "five & dime" or "dime store," the variety store became a fixture in the American lifestyle of that time. (Buena Park Historical Society.)

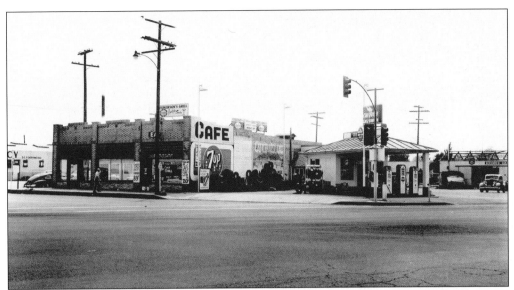

In 1949 the southwest corner of Manchester Boulevard and Grand Avenue had taken on a modern look. The Chevron Gas Station sported a sign saying "Chevron Credit Cards Accepted." The Wilkerson's Grill was offering "Take Out Burgers 20¢," "Merchants Lunch 50¢," and "Complete Dinner 89¢." (Buena Park Historical Society.)

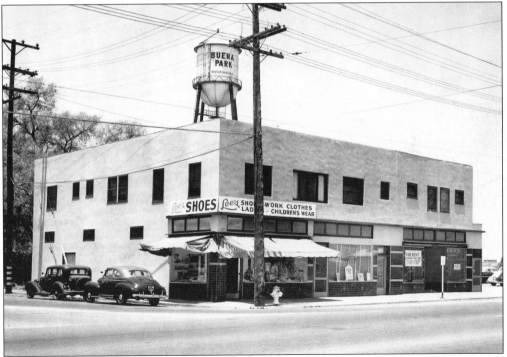

On the corner of Ninth Street and Grand Avenue (now Beach Boulevard), the Warren Block in the 1940s had gone through several modernizations since being originally built. Still standing today, this area has gone though further changes, including the removal of the water tower in 1967. Most people still remember the structure subsequent to this as the Western Auto building. (Buena Park Historical Society.)

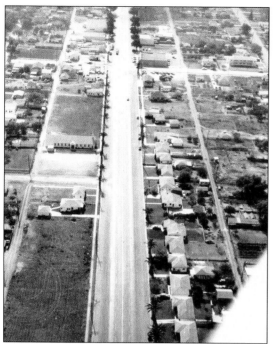

This 1940s view looking south on Grand Avenue (now Beach Boulevard) shows the First Baptist Church of Buena Park just left of center as well as the residential development growing north from the Southern Pacific Railroad for the mile stretching to the Santa Fe Railroad. Today, the houses beside the thoroughfare have been replaced by commercial development. (Buena Park Historical Society.)

The Santa Fe Railroad did not build a promised depot in Buena Park in 1887 so city founder James A. Whitaker physically moved his buildings one mile south where the Southern Pacific Railroad built their depot, which sustained early development. Decades later the Santa Fe Railroad built this depot in Buena Park on a sugar beet farm a mile north of town. (Buena Park Historical Society.)

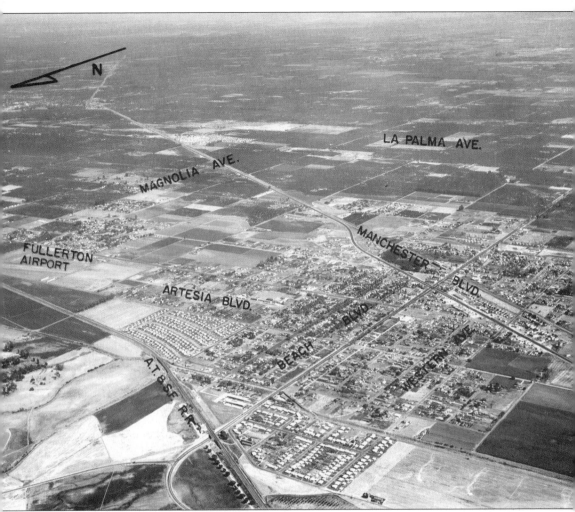

This high-flying photograph of Buena Park in the 1940s shows residential development had grown north, branching out along Beach Boulevard (formerly Grand Avenue) from downtown at Manchester Boulevard toward the Atchison Topeka & Santa Fe Railroad. But Buena Park was still completely surrounded by farmland. (Buena Park Historical Society.)

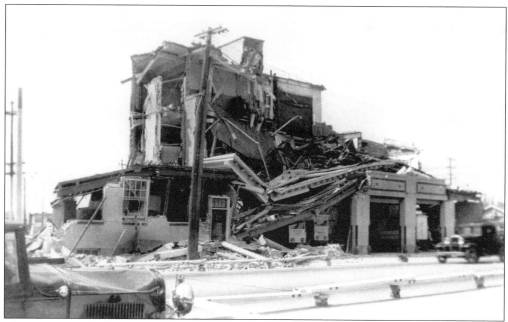

The Long Beach earthquake hit on March 10, 1933 at 5:55 p.m. with a 6.4 magnitude epicenter 3 miles south of downtown Huntington Beach on the Newport-Inglewood Fault. A total of 120 people died, four in Orange County, and over $50 million worth of property damage was done over a 75,000-square-mile area including, of course, Buena Park. (Buena Park Historical Society.)

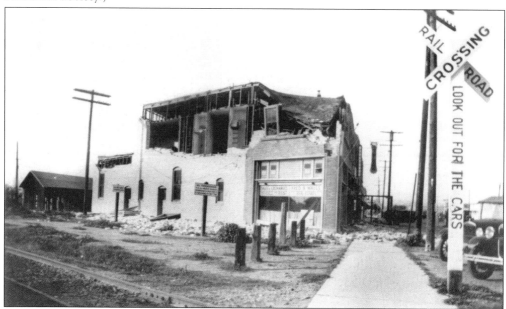

The lateral movement of the Long Beach earthquake primarily damaged structures of unreinforced masonry like this Buena Park real estate office on Grand Avenue at the Southern Pacific Railroad tracks. This type of damage never happened again thanks to California assemblyman Charles Field and a law called the Field Act passed on April 10, 1933. (Buena Park Historical Society.)

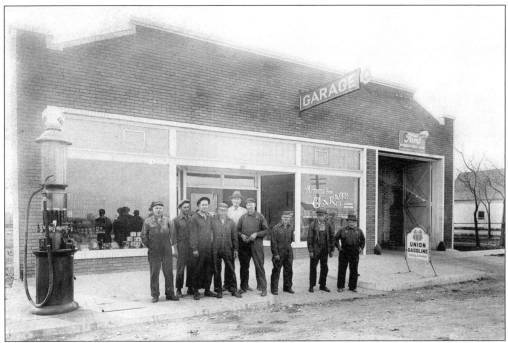

The employees of the Mitchell Brothers' Garage, shown here in 1922, from left to right, are Sy Kimmel, Winfred Middleton, Chuck Robinson, Bill Mitchell, Bob Waralmount, unidentified, Dave Mitchell, Ira Mitchell, and "Uncle" Jim Mitchell. (Buena Park Historical Society.)

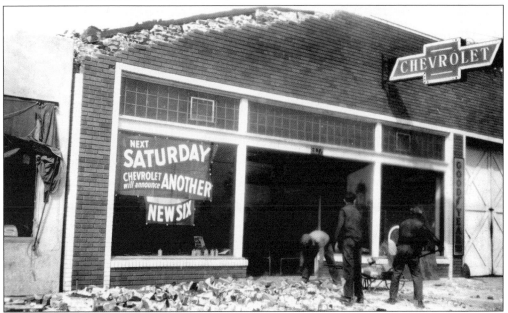

Cleanup is performed after the Long Beach earthquake at the Mitchell Brothers' Garage. The Uniform Building Code of 1927 had the first comprehensive earthquake code requirements. After the Long Beach earthquake, the revised Uniform Building Code of 1935 dealt with lateral earthquake movement and changed building codes and oversight authority throughout California. (Buena Park Historical Society.)

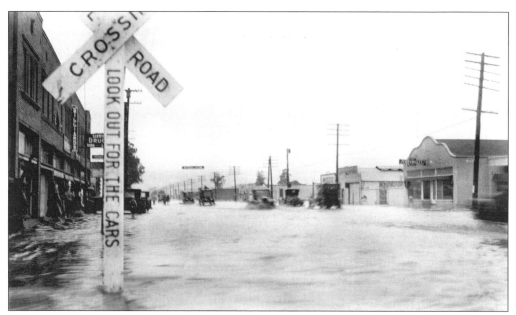

In this 1927 photograph, Grand Avenue has become a river of floodwater while early automobiles make their way perhaps more successfully than would low-profile modern cars. More perplexing is the sign at the Southern Pacific Railroad tracks, which had taken on new meaning considering the flood. (Buena Park Historical Society.)

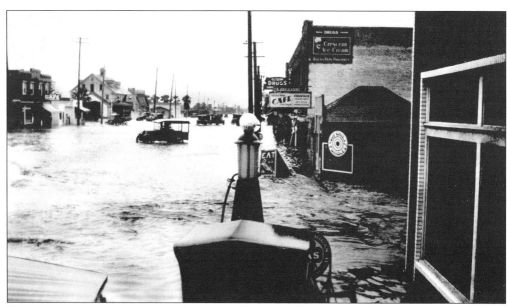

On the flood plain between the Santa Ana River and San Gabriel River, Coyote Creek, Brea Creek, and Fullerton Creek all flow through the flats of Buena Park. Before the engineering and installation of flood controls on those creek beds, scenes such as this along Grand Avenue in 1927 were too often part of the rainy season each winter. (Buena Park Historical Society.)

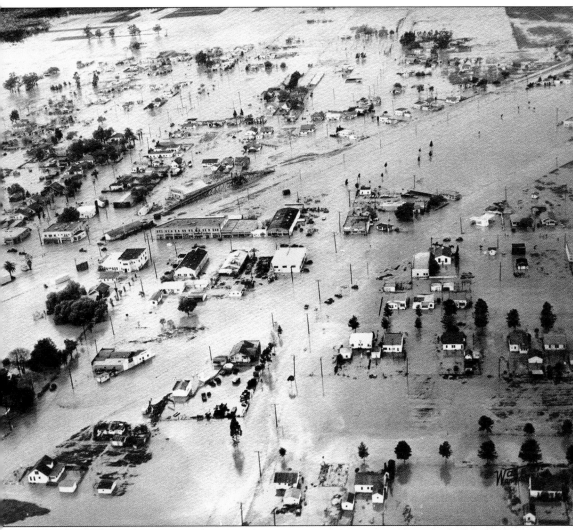

Buena Park endured a flood on March 3, 1938 that altered its future after eight inches of rain fell rapidly in local mountains. In this photo, Manchester Avenue and the Southern Pacific Railroad seem on opposite sides of a river running diagonally from lower left to upper right. This outlines the area excavated for the Santa Ana Freeway in 1954. (Buena Park Historical Society.)

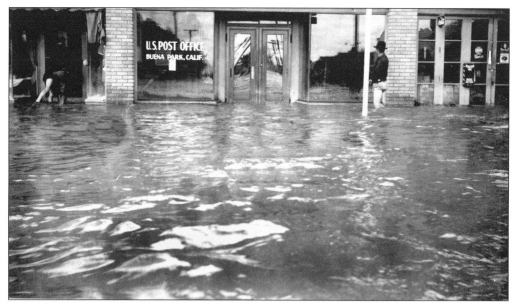

This was the U.S. Post Office in Buena Park on March 3, 1938. Whether fact, lore, or myth, eyewitnesses claim that counter service was open during the flood and some people entered the post office via boat. "Neither snow, nor rain, nor heat, nor gloom of night stays these couriers from the swift completion of their appointed rounds." (Buena Park Historical Society.)

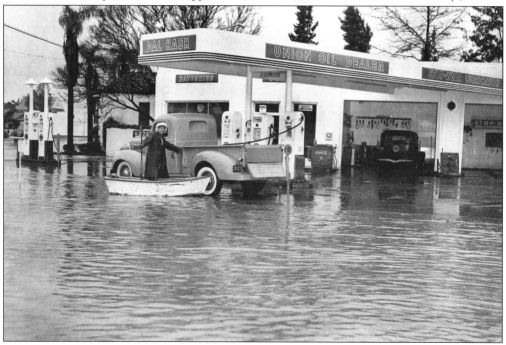

At Manchester Boulevard and Grand Avenue on March 3, 1938, floodwaters encroach on daily activities, if not completely forestalling them. This was the beginning of the end, as flood-control districts were established to prevent future disasters. Today, successful prevention is taken for granted but the 1938 flood was the historic call to action. (Buena Park Historical Society.)

Here Coyote Creek gets reinforced as a flood-control channel. The original business district of Buena Park was midway between Coyote Creek and Brea Creek to the north and Fullerton Creek to the south. Related aquifers may have served local wells but during the rainy seasons the area was always in peril of flooding from natural drainage. (Buena Park Historical Society.)

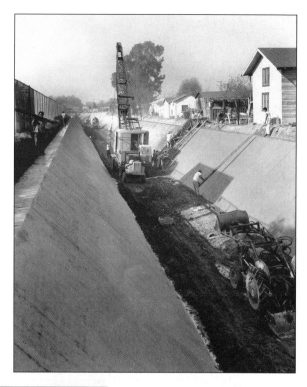

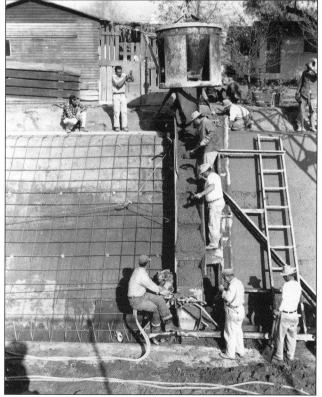

Part of the flood-control system, Los Coyotes Channel is shown being lined with cement and reinforcement bar. Although close calls and minor flooding have resulted since this work was done, abutting properties most often endure the annual rainy season without incident and Buena Park in general has avoided the disasters of the early years. (Buena Park Historical Society.)

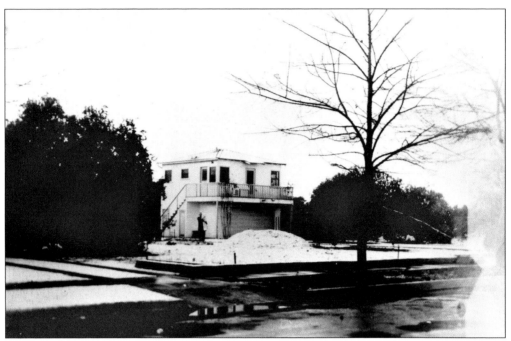

Some acts of God may have been less devastating than the flood of 1938 but were nonetheless awe-inspiring and noteworthy. This 1949 photo shows the first and last recorded measurable snowfall in Buena Park. The buildup in front of this unknown location reportedly was from street clearing. (Buena Park Historical Society.)

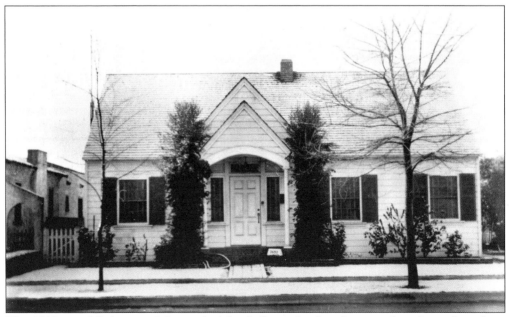

The 1949 snowfall decorated the yard of the Sullivan family, who contributed significantly to the economic, cultural, and educational fabric of Buena Park. The house sits across the street from the site of Buena Park's first grade school. The last time the school was rebuilt, it was named J.B. Sullivan School. (Buena Park Historical Society.)

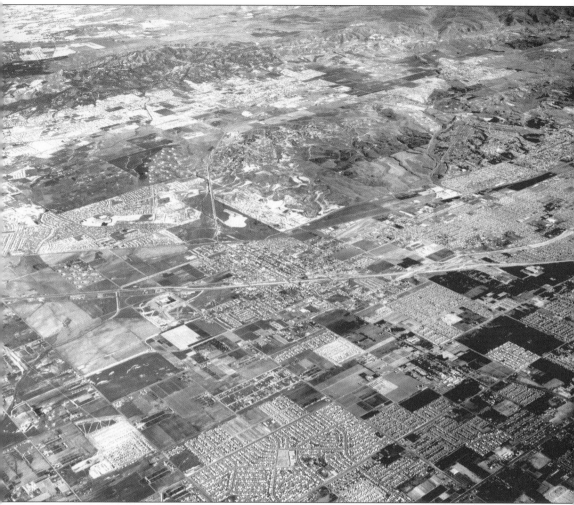

This *c*. 1957 aerial photograph looking northeast shows the Santa Ana Freeway running horizontally through the center. The developed area at the vertical center is Buena Park. Slightly up and left, Beach Boulevard (formerly Grand Avenue) curves left into Stage Road, first the route of Los Angeles stagecoaches, then the Atchison Topeka & Santa Fe Railroad. A right turn connects with California State Highway 39 past La Mirada into La Habra. (Buena Park Historical Society.)

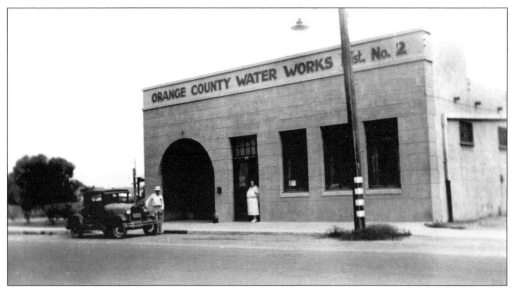

In the 1930s, Claude Allin (next to car) was water commissioner for the Orange County Water Works District No. 2 at this then-new facility on Ninth Street in Buena Park. Emma Bassler (in doorway) was treasurer. The water tower was erected behind this building, which, over the decades, also housed the fire department, first temporary city hall, Buena Park Historical Society, Girls' Club of North Orange County, and a neighborhood boxing club. (Buena Park Historical Society.)

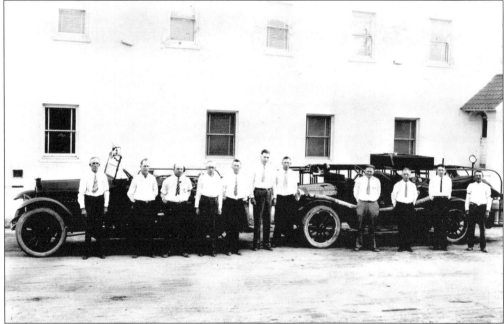

Members of the Buena Park Woman's Club organized their husbands and sons into the first volunteer fire brigade in Buena Park. During the 1930s a firehouse was built on property loaned by Arni Nelson at the southeastern corner of Buena Park Lumber & Hardware. Ironically, that building burned down while everyone in town attended a socially prominent wedding at the First Congregational Church of Buena Park. (Sam Winner.)

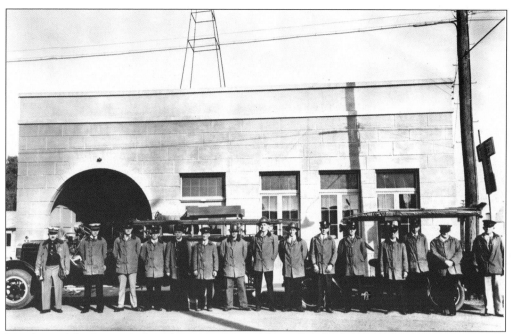

Members of the Buena Park Volunteer Fire Brigade are pictured in front of their firehouse. The hook-and-ladder truck was backed in through the arched doorway to await calls. Note the pyramidal steel stanchions of the water tower above and behind this former water district building on Ninth Street west of Grand Avenue (now Beach Boulevard). (Sam Winner.)

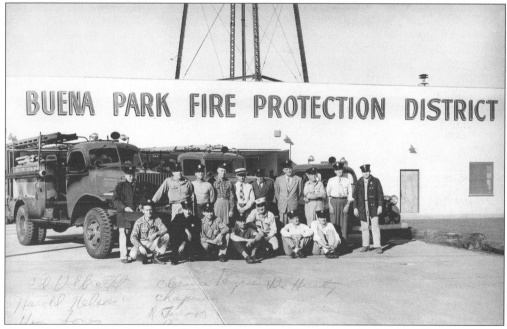

Pictured here in 1953, the Buena Park Fire Protection District was sharing the old water district building (note water tower legs) with the first elected officials and paid staff of the newly incorporated City of Buena Park. Public safety was one of the issues driving the incorporation movement so some volunteers eventually became city employees. (Sam Winner.)

Still housed in the water district building around 1957, firemen were busy polishing the first equipment purchased for the Buena Park Fire Department, a new department of the City of Buena Park. This normal activity went on while construction was underway less than a block southeast on the first civic center. (Sam Winner.)

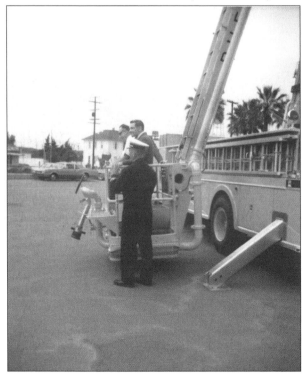

This "cherry picker," Buena Park's first yellow fire rig—a color then deemed more visible—was a substantial investment for the City of Buena Park in the early 1970s. It is seen here in the front parking lot of the civic center with the Stage-Stop Hotel directly across Beach Boulevard behind Mayor Jesse Davis (short sleeves and glasses), who is about to be taken on a ride. (Buena Park Historical Society.)

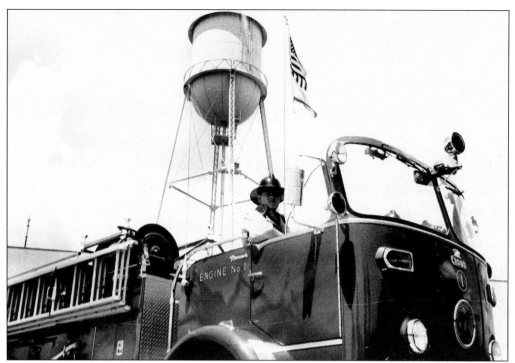

The Buena Park Water Tower, Old Glory, Fire Engine No. 1, and part of the water district building, all iconic images of America, are seen here just above the ladders. Icons may last forever but not so historical landmarks. Today nothing in this photo exists except "O beautiful for spacious skies." (Buena Park Historical Society.)

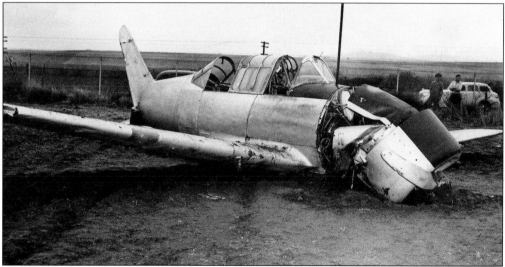

When airplanes take off from Fullerton, where the runway ends, Buena Park begins, meaning that most crashes at Fullerton Airport actually come down in Buena Park. On November 20, 1950 this plane crashed on vacant land. Today that land is covered with commercial, industrial, and residential buildings. The Fullerton Airport Advisory Committee, including residents of Buena Park, was established to deal with public safety–related issues. (Buena Park Historical Society.)

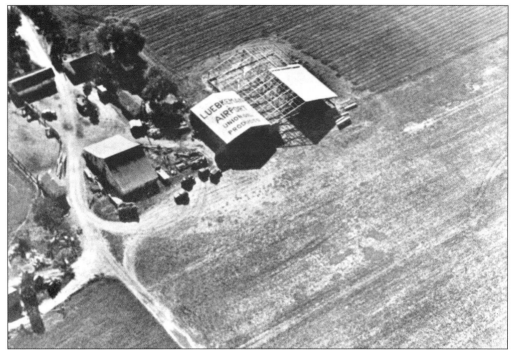

Anton Luebkeman and his wife came to California from Germany in 1904 and bought 140 acres of land in Buena Park in 1910. Beginning in 1911, artesian wells allowed Luebkeman to lease out his land for others to cultivate. When Walter Knott needed more production, he too leased land from Luebkeman. Knott even had Luebkeman's sons, Henry, Walter, and Carl, plow and prepare their land for Knott to plant boysenberry vines. (Buena Park Historical Society.)

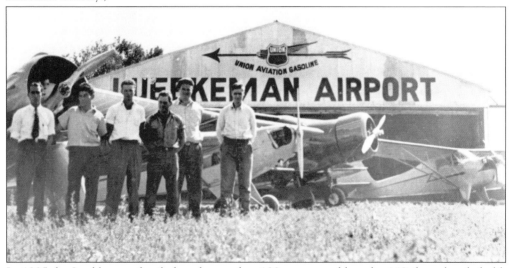

In 1935 the Luebkeman family bought another 100 acres to add to the 140 they already held. Here they built an airstrip in 1938 and rented out hangar space to airplane enthusiasts such as Howard Hughes. Always industrious, Luebkeman and his sons excavated the lakes at Knott's Berry Place, rented their classic cars to the movie industry, and bought and sold farm machinery in Mexico. (Buena Park Historical Society.)

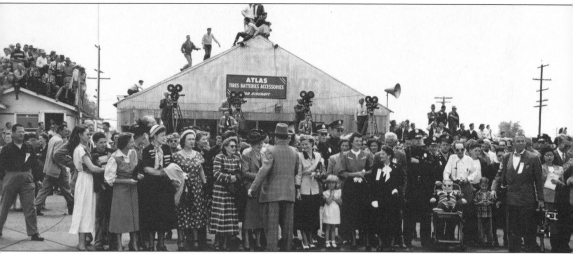

Shown here in 1940, 20th Century Fox Studios rented the Luebkeman Airport for five days to film part of the movie *The Great American Broadcast* starring Alice Faye, Jackie Oakie, John Payne, and Cesar Romero. During World War II the airport was used for "touch and go" flight training. The Luebkeman Airport was located in the Aldon Tract off Crescent Avenue between Hansen Road (now Knott Avenue) and Valley View Street. (Buena Park Historical Society.)

Three
SUBURBAN GROWTH

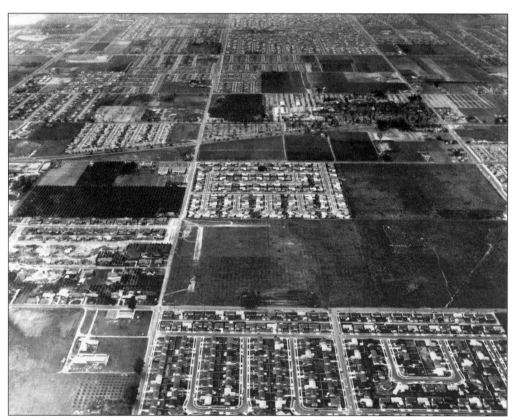

This photograph, taken January 31, 1958, shows the initial grading (below left of center) of the street where the author's home is located. Looking west along Crescent Avenue from the first major cross street, Dale Street, the parking lots and buildings of Knott's Berry Farm can be seen just past the diagonal of California State Highway 39, called Beach Boulevard in Buena Park. (Gail S. Dixon.)

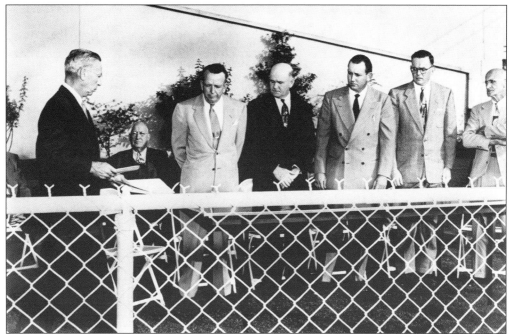

On January 27, 1953, Orange County clerk B.J. Smith swore in the first city council of the new City of Buena Park, which was voted in as a general law rather than a charter city. Shown here, from left to right, are Grady Travis, Calvin Culp, Garner McComber, Tom Steizner, and Joe Webber. The new city council elected Grady Travis as the first mayor of the City of Buena Park. (Buena Park Historical Society.)

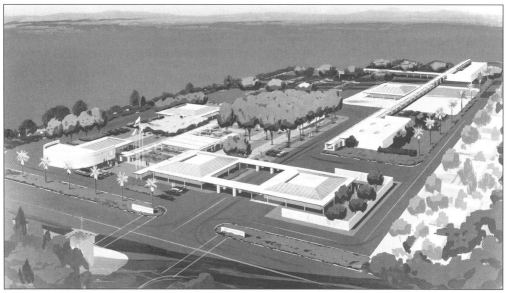

In this architectural rendering, the first Buena Park Civic Center looks idyllic. It turned out just as beautiful as expected, if unexpectedly inefficient. Landscaped parkways separated buildings so that employees had to reach unconnected departments by trudging along walkways under lattice open to the elements. Almost immediately, practical modifications were required. (Buena Park Historical Society.)

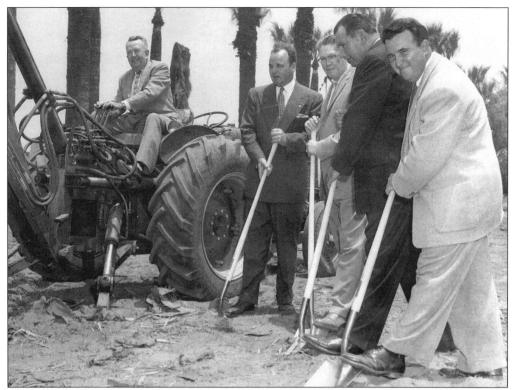

Mayor Grady Travis "operates" the backhoe at this groundbreaking for the first City of Buena Park Civic Center. In 1956 the U.S. Census Bureau revised estimates so the civic center was built for a population of 50,000 as forecast for 1975. However, three years after the civic center was completed in 1957, Buena Park's population was already 46,401. The population was 78,282 in the 2000 Census. (Buena Park Historical Society.)

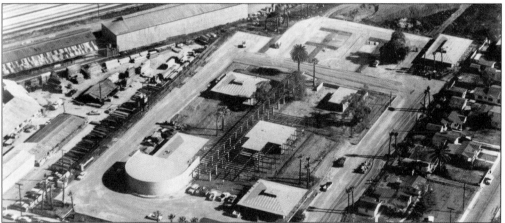

In December 1957, the first Buena Park Civic Center was nearing completion. The city eventually bought and razed the houses shown along the right of this photo to expand the complex. Note the Santa Ana Freeway across the top. Between the civic center and the freeway, a large warehouse sits on the back of the cannery property site of the Lily Creamery. On the left, Buena Park Lumber & Hardware Company stacked lumber as high as buildings because construction was booming. (Buena Park Historical Society.)

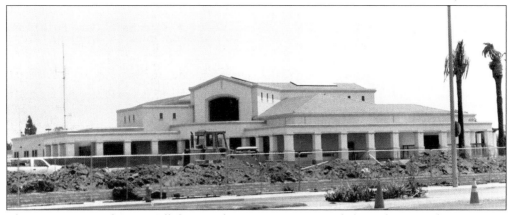

The new Buena Park City Hall, here under construction, was dedicated on October 13, 2003, which coincided with the 50th anniversary of the town's incorporation. Built on the same site as the original 1958 multi-structure campus, all city departments except police are now under one roof for the first time. Voters have yet to pass a bond issue to build new facilities for the police department on vacant land located out of frame on the left. (Buena Park Chamber of Commerce.)

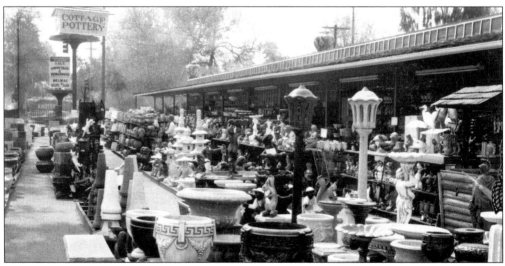

There was a time when no trip to Buena Park was complete without stopping by Cottage Pottery, opened in 1949 on the busy route to the beaches, California State Highway 39 (or Beach Boulevard, formerly Grand Avenue), and across La Palma Avenue from Knott's Berry Place. The store attracted generations of shoppers to Buena Park but closed in the 1980s. The land was then developed into a strip mall. (Buena Park Chamber of Commerce.)

This view looks south along Beach Boulevard from the west side in front of Groves Hardware in the 1950s. The bane of a commuter society, smog, was settling in and obscuring the view of the cannery with its smokestacks and water tank in the distance. (Buena Park Historical Society.)

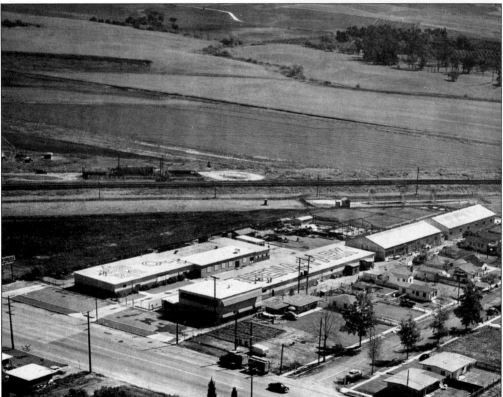

Dr. Carl Rehnborg and his wife, Edith, moved their company, Nutrilite Inc., to Buena Park in 1946. Dr. Rehnborg invented the multi-vitamin and multi-level marketing while Mrs. Rehnborg made a line of cosmetics. Nutrilite eventually became part of its largest distributor, Amway. Seen here in the 1940s, signs on the buildings' roofs directed airplanes to the Fullerton Airport. In the background, Coyote Hills had been home to Rancho Los Coyotes and would be home to Bellehurst. (Buena Park Historical Society.)

Buena Park Kids Inc. was formed in 1949 to organize recreational programs for kids ages 8 to 18 after a failed attempt to do so through the Park, Recreation, and Parkway District. Here at Bellis Park, the grandstand in the background was the home of the famous Buena Park Lynx women's softball team. (Buena Park Historical Society.)

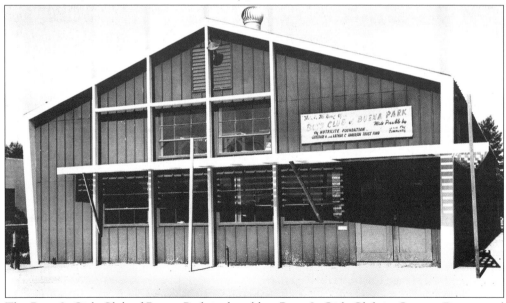

The Boys & Girls Club of Buena Park is the oldest Boys & Girls Club in Orange County and was founded in 1948 by Carl and Edith Rehnborg, who had moved their business, Nutrilite Inc., to Buena Park in 1946. The club has provided a "home away from home" for more than 64,000 children since its inception. (Buena Park Historical Society.)

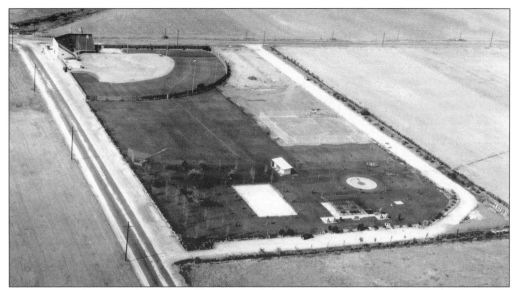

A group of schoolgirls, playing softball at Lindbergh School after class, was organized into a team in 1935. By 1938 the Buena Park Lynx were playing in the Pacific Coast League. During the 1940s the Buena Park Lynx contended for national championships and "put Buena Park on the map." George Bellis, president of the Buena Park Chamber of Commerce, organized a community effort to rent ten acres of Sanitary District land and built the above softball field and grandstands for the team. Bellis Park was also the original site of Buena Park Silverado Days. (Joan Alsup Galloway.)

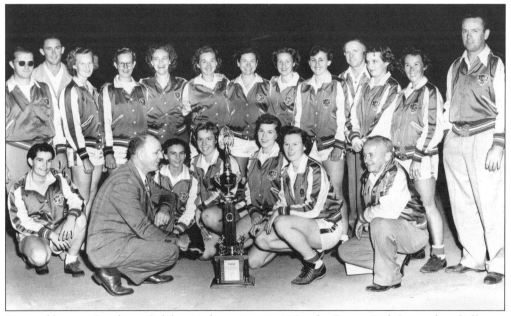

Pictured here as Southern California champions in 1951, the Buena Park Lynx played all over America and Canada during their 20-year run. As amateurs, the whole team got travel expenses but no players were paid individually. Originally sponsored by Buena Park Merchants Association, the team was known as the Merchants from 1935 until 1939 when the women chose their own name, Buena Park Lynx. (Joan Alsup Galloway.)

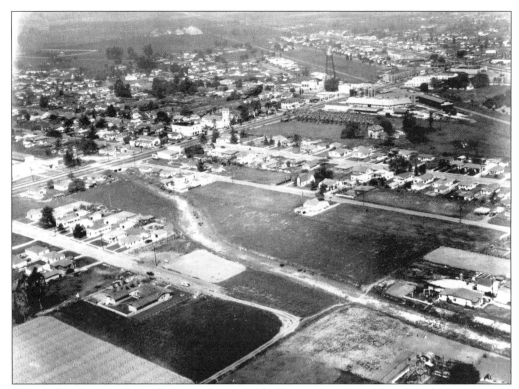

This 1954 photograph looking northwest with downtown Buena Park in the upper right quadrant shows, from left to right along Grand Avenue, the Buena Park Woman's Club, Masonic Temple, First Congregational Church, Stage-Stop Hotel, and the water tower. The L-shaped grading in the foreground was to become the corner where Melrose Street turns into Brenner Avenue. (Buena Park Historical Society.)

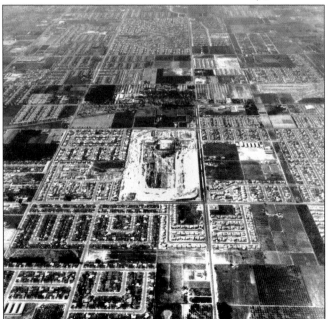

Looking west along La Palma Avenue on February 24, 1959, the development of the Buena Park Regional Shopping Center on 80 acres between Dale Street and Stanton Avenue appears as cleared land except for the outline of the foundation for the Sears, Roebuck & Company building. Knott's Berry Farm is the next landmark west, separated from the mall by crop fields. (Gail S. Dixon.)

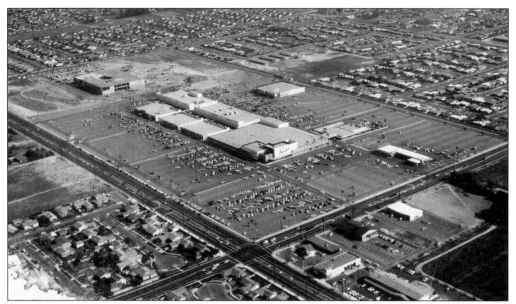

Shown here in 1963, the Buena Park Regional Shopping Center was reaching toward the May Company building (under construction, left center). Looking southeast from the corner of La Palma Avenue and Stanton Avenue, the rural landscape had become urban with most of the open land surrounding new schools, not farmhouses. (Buena Park Historical Society.)

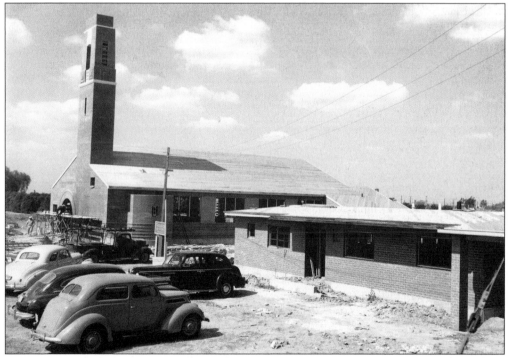

Saint Pius V Catholic Church was organized in 1948 and met for a while in the homes of parishioners. In 1950 the first services were held in the sanctuary under construction in this photograph. Subsequent growth led to building new facilities on the same location. Services were first held in the new sanctuary in 1995. (Buena Park Historical Society.)

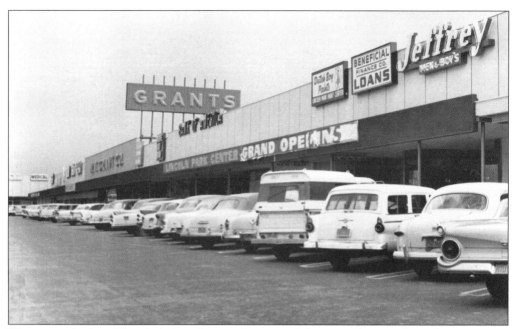

The new suburban lifestyle led to decentralization of shopping districts from downtowns to neighborhood strip malls. At its grand opening in the late 1950s, Lincoln Park Center, initially built on 12 acres of a 20-acre site at Knott Avenue and Lincoln Avenue, had lots of convenient parking for the new two-car family. (Buena Park Historical Society.)

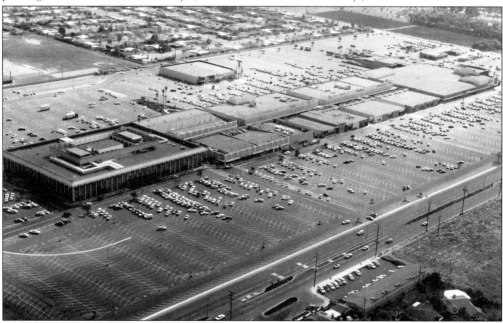

By 1964 the Buena Park Regional Shopping Center was completed and operating successfully. Anchored by May Company on the east and Sears, Roebuck & Company on the west, the formula for this new suburban mall was much the same as any other. For years the Sears at Buena Park Mall was the highest grossing in the United States. (Buena Park Historical Society.)

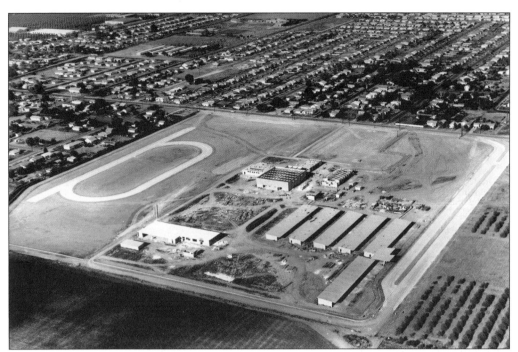

Shown here under construction, Buena Park High School was opened on September 11, 1956 with an enrollment of 508 students. Under the first principal, Richard Spaulding, enrollment grew to 2,200. Prior generations of Buena Park students graduated from Fullerton Union High School, which opened in 1893 with eight students. (Buena Park Historical Society.)

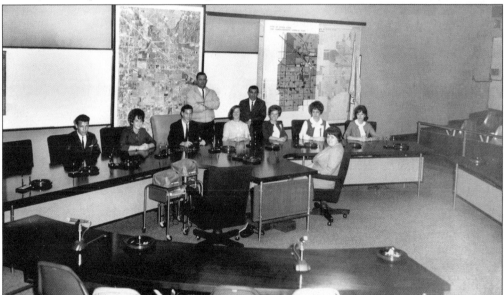

In the 1960s a student-government class spends a day learning the functions of local government by role-playing as the city council in the council chambers of the City of Buena Park. The council chambers were later upgraded but ultimately abandoned and destroyed when asbestos abatement proved more expensive than reconstruction. (Buena Park Historical Society.)

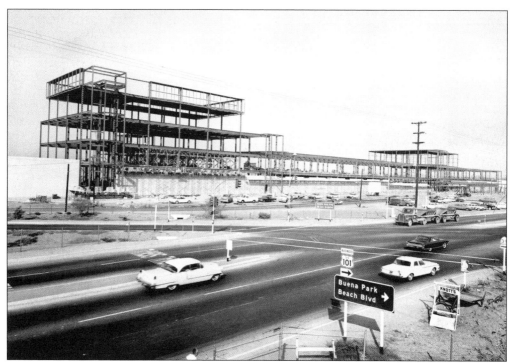

With framing underway in 1964, the Nabisco factory was on its way to becoming the building most identified with Buena Park. The location, right next to the northbound on-ramp to the Santa Ana Freeway, was on Artesia Boulevard at Manchester. This was Buena Park's "front door" to access Knott's Berry Farm, the entertainment corridor, and the suburban housing tracts. (Buena Park Chamber of Commerce.)

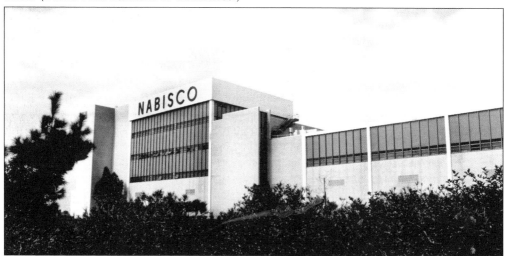

The Nabisco plant was the gateway to the City of Buena Park from the north. Unhappy with the decimation of downtown Buena Park, city fathers insisted that the Santa Ana Freeway be constructed below grade with no on-ramps or off-ramps within city limits. It was believed this would decrease traffic congestion but only made it worse. Not until the 1990s was there direct access to Beach Boulevard, also known as California State Highway 39. (Buena Park Chamber of Commerce.)

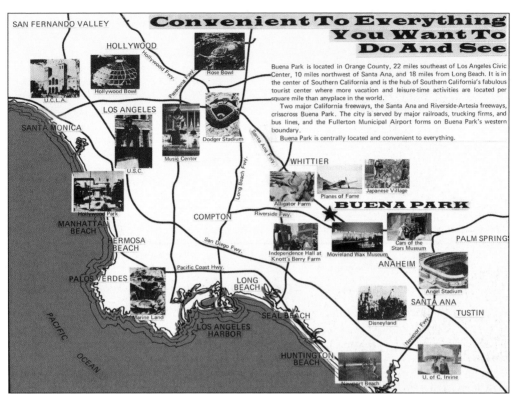

Convenient To Everything You Want To Do And See

Buena Park is located in Orange County, 22 miles southeast of Los Angeles Civic Center, 10 miles northwest of Santa Ana, and 18 miles from Long Beach. It is in the center of Southern California and is the hub of Southern California's fabulous tourist center where more vacation and leisure-time activities are located per square mile than anyplace in the world.

Two major California freeways, the Santa Ana and Riverside-Artesia freeways, crisscross Buena Park. The city is served by major railroads, trucking firms, and bus lines, and the Fullerton Municipal Airport forms on Buena Park's western boundary.

Buena Park is centrally located and convenient to everything.

When Kraft Company decided to build a processing plant on the West Coast, they commissioned a demographics study using seven different approaches. Each concluded that Buena Park was the most central location. Kraft built in Buena Park and Buena Park got its motto, "Center of the Southland." (Buena Park Chamber of Commerce.)

In the late 1960s, the J.C. Penney Company built this 800,000-square-foot distribution center at the northeast corner of Orangethorpe Avenue and Valley View Street. In the 1950s the same location was of interest to Walt Disney as a potential location for building Disneyland. Most prognosticators of the time deemed Disneyland a probable failure, so Buena Park declined. (Buena Park Historical Society.)

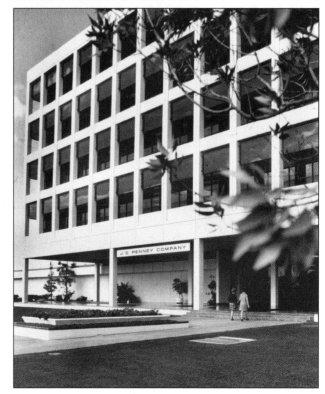

On December 7, 1967, the 100,000-gallon tank that provided water from the 1930s until 1965 was disassembled and reportedly shipped to a community in Indiana. To meet population growth, the new 20 million–gallon reservoir used pumps to provide water pressure rather than the water tower's gravity feed. (Buena Park Historical Society.)

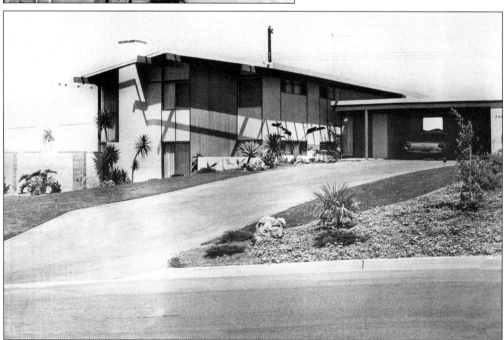

Bellehurst became New Bellehurst when financing was found to move the residential development forward. Upscale modern houses of the 1960s, shown here, surround the Los Coyotes Country Club and have since matured into the exclusive golfing-based community originally planned. (Buena Park Chamber of Commerce.)

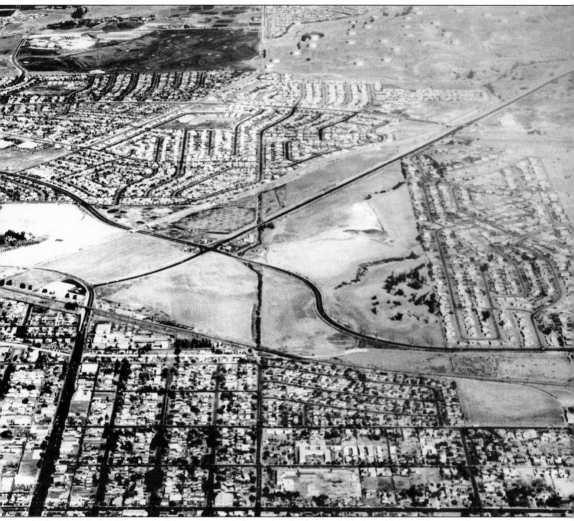

The pie-shaped wedge on the right of this 1960s photo is a residential development called Bellehurst. Built on former Emery Ranch land, Bellehurst attracted the attention of national magazines as a planned community. However, construction came to a standstill and the area became a "ghost town" due to various factors, including a general strike by a labor union, an unfounded federal government investigation, and sinking into receivership. Not surprisingly, the area came under media scrutiny again. (Buena Park Historical Society.)

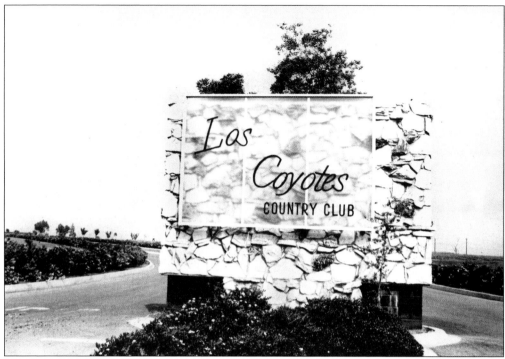

Los Coyotes Country Club opened on November 1, 1957 as the Fullerton Country Club owned by Cliff Jones. LCCC was subsequently sold to R.A. Watt in 1967, Boise Cascade in 1967, and Japan-based SOWA, USA in 1973. McAuley LCX Corporation, owned by Chuck and Ida McAuley, purchased LCCC in 1980 and has owned it ever since. (Buena Park Chamber of Commerce.)

The clubhouse of Los Coyotes Country Club reflected the architectural styles at the time of its construction in 1957. The original structure, gutted by fire on November 28, 1962, was rebuilt on the same location and re-opened in 1964 as shown. That structure was taken down and replaced with a larger Spanish Revival–style clubhouse that opened in 2003. (Buena Park Chamber of Commerce.)

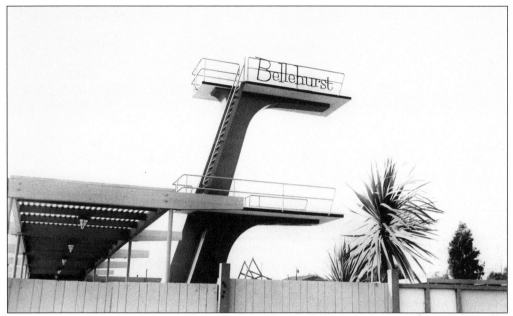

Through various owners, Los Coyotes Country Club has had a series of different names, beginning with Fullerton Country Club in 1957, Bellehurst in 1967, New Bellehurst in 1970, and Los Coyotes Country Club in 1973. This undated photo of the diving platforms at the club's swimming pool was taken between 1967 and 1970. (Buena Park Chamber of Commerce.)

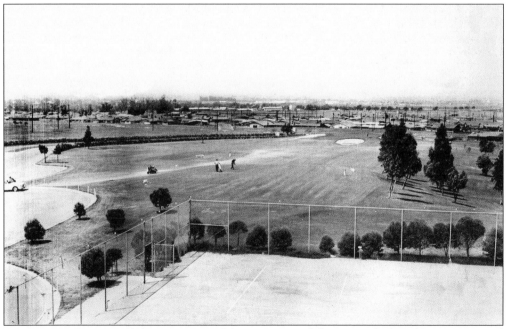

Los Coyotes Country Club is a private club consisting of three nine-hole golf courses named Lake, Valley, and Vista, seen here in the 1960s. The grounds of the courses themselves include the site of the original Rancho Los Coyotes adobe headquarters and hacienda. The present name and clubhouse architecture are truer to the spirit of the old rancho. (Buena Park Chamber of Commerce.)

Since the 1960s the Buena Art Guild has been fostering visual arts in the community. For a number of years they sponsored an outdoor juried art show known as the Knott's Roundup. Here Buena Art Guild multi-term president Roy Dillon awards a ribbon to a winning artist in November 1976. (Marge Rollins.)

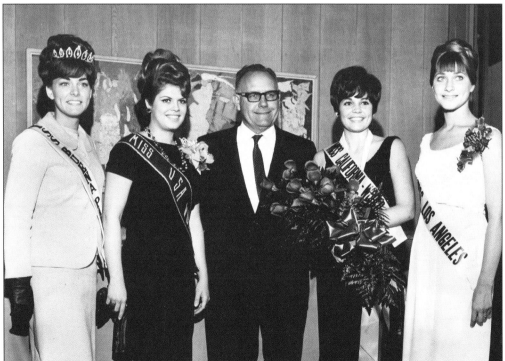

Surrounded by beauty queens in 1967, Mayor Jesse Davis participates in ceremonies announcing the affiliation of the Miss Buena Park Contest with the Miss World Beauty Pageant. The Miss Buena Park Contest has gone through various affiliations over the years but remains a stand-alone pageant at present. Each October the reigning Miss Buena Park is also crowned Miss Silverado for Silverado Days. (Buena Park Historical Society.)

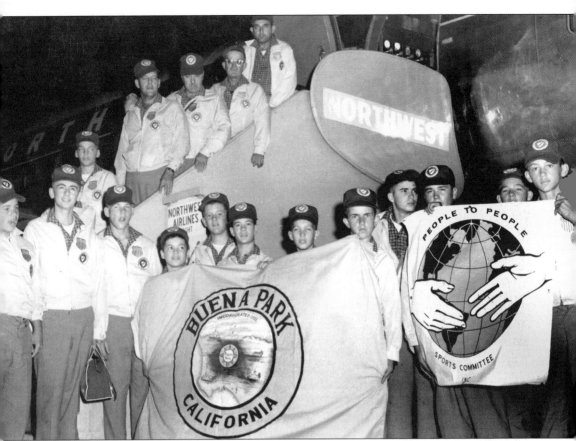

The Buena Park Junior All-Star baseball team arrives in Japan on August 26, 1959 for a series of games with Japanese counterparts. The program was co-sponsored by the People-To-People Sports Committee, the Sportsmen's Club of Buena Park, the City of Buena Park, and Northwest Airlines. (Buena Park Historical Society.)

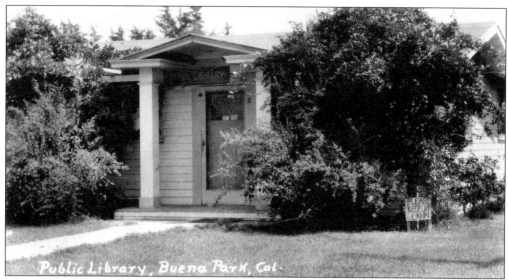

In 1905 Mrs. D.W. Hasson, wife of Buena Park's first medical doctor, and Reverend Lazarus, minister of the Methodist Church, donated books and organizational skills to found the Buena Park Library in a donated room at the Lily Creamery. Through the efforts of Mrs. Minnie Meyers and the Buena Park Woman's Club, an election was held in June 1919 to establish the Buena Park Library District. In 1920 a building of 396 square feet was constructed on the northeast corner of Grand Avenue (now Beach Boulevard) and Court Street to house 283 books. (Buena Park Historical Society.)

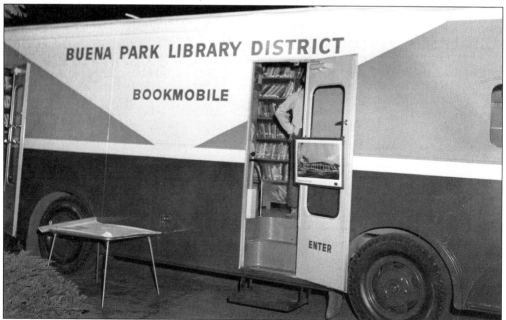

The bookmobile of the Buena Park Library District, seen here at a Buena Park Police Department open house in the 1960s, offered books to those unable to get to the library. On the open door hangs an artist's rendering of the proposed new library building, subsequently built on La Palma Avenue and opened in March 1969. With about 115,000 volumes, the current circulation is 37,000 books per month. (Buena Park Historical Society.)

Taking advantage of the Work Projects Administration set up by the federal government during the Depression, the Buena Park Library District began construction in 1934 of a new library building in front of the existing structure to utilize the old space as well. Completed and opened in March 1935, the new structure held 6,294 books with an astounding circulation of 3,000 books per month. (Buena Park Historical Society.)

Four
DOWN-HOME FUN

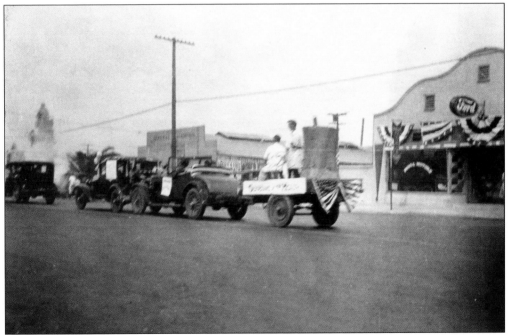

During the 1930s, family cars and utility vehicles with hand-painted signs were about the extent of these earliest Buena Park Hometown Day Parades. From this country-town homespun affair, a tradition of community pride and self-sufficiency evolved. With television broadcasts and aircraft flyovers, today's Silverado Days Parade has come a long way. (Buena Park Historical Society.)

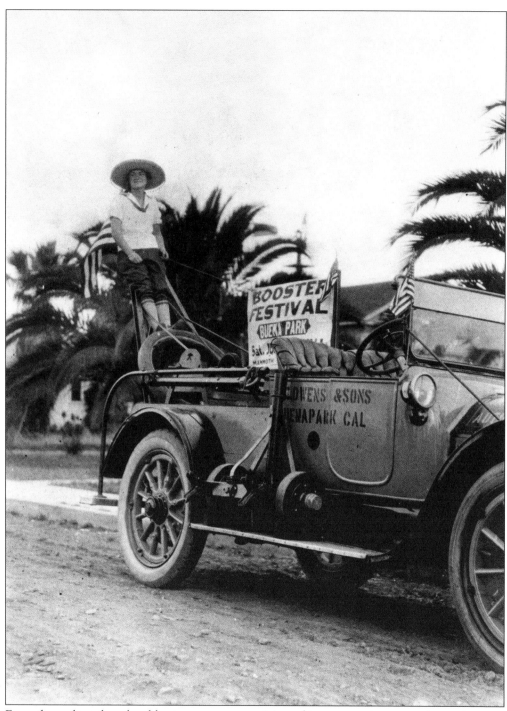

From the earliest days, local business owners participated in community promotion to increase their sales. This 1912 Buena Park Booster Festival parade entry is shown in front of the George H. Warren Company store on Grand Avenue (now Beach Boulevard) at Ninth Street. The Buena Park Booster Festival was a precursor to community events that followed, such as Hometown Day and Silverado Days. (Buena Park Historical Society.)

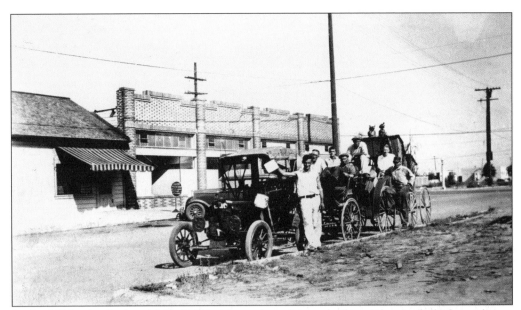

In the 1930s, this hodgepodge of old carriages, horseless and otherwise, were linked together as a Hometown Day Parade float good for a laugh. At the end was an outhouse on wheels carrying a sign that read "Buena Park Sanitary Office." (Buena Park Historical Society.)

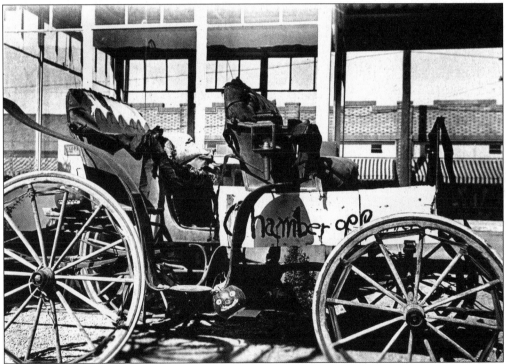

In 1932, a group of community leaders got together to promote business in Buena Park. A Western theme was chosen for a Buena Park Hometown Day Parade that became an annual event and evolved into Silverado Days. This 1930s-era entry boasts a facetious sign proclaiming a tattered carriage as the "Chamber Office." (Buena Park Historical Society.)

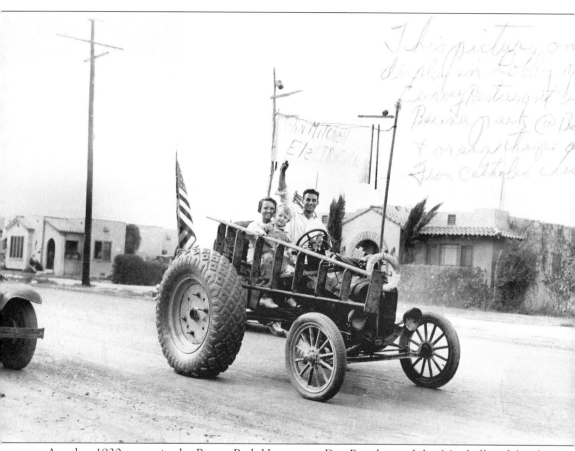

Another 1930s entry in the Buena Park Hometown Day Parade was John Mitchell and family driving the family tractor carrying an American flag. Mitchell was clearly advertising his services as an electrician. Promoting business was the original idea behind the event. (Buena Park Historical Society.)

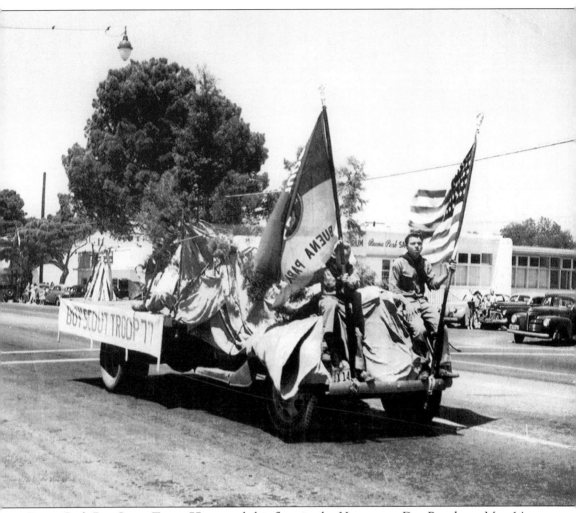

Buena Park Boy Scout Troop 77 entered this float in the Hometown Day Parade on May 14, 1949. There were more than 109 entries in that parade. Mr. Lynn Green was grand marshall, and the El Toro Marine Band was the first of several bands. The event was "presented under the auspices of, Business Men's Division, Chamber of Commerce, Buena Park, Calif." (Buena Park Historical Society.)

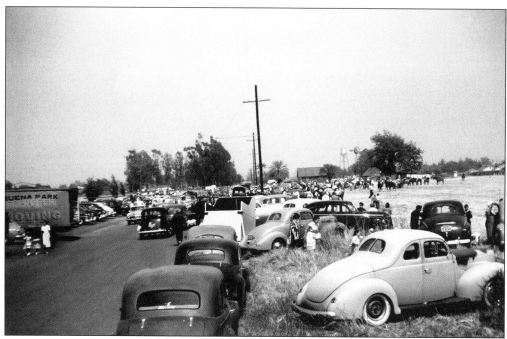

This photo, taken around 1950, shows the Buena Park Hometown Day Parade forming as people park and leave their vehicles next to farm fields along Grand Avenue (now Beach Boulevard) to participate in the annual event. Compared to the modern day, the area appears so rural that viewers may question the photograph's location until the water tower is pointed out on the horizon to the south. (Buena Park Historical Society.)

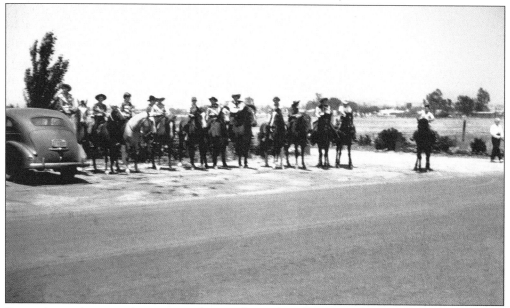

Equestrian units were always part of even the earliest Buena Park Hometown Day Parades because many people had horses in such a rural community. Lots of folks who were counted as citizens of Buena Park in those days actually lived on farms outside of town. Here people await the start of the parade on their mounts, c. 1950. (Buena Park Historical Society.)

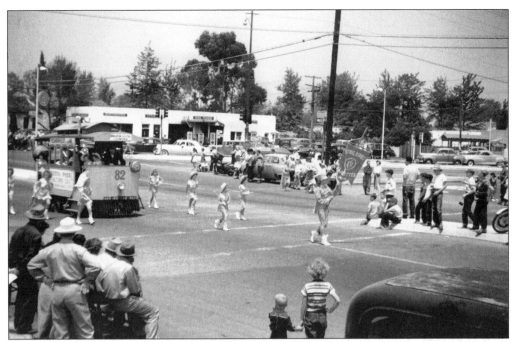

Sybil Ring's Majorettes strut and twirl in front of a miniature trolley during a Hometown Day Parade around 1950. The parade was proceeding south on Grand Avenue but automobile traffic on Manchester Boulevard does not appear to be blocked from crossing the parade route, as traffic signals are operating as usual. (Buena Park Historical Society.)

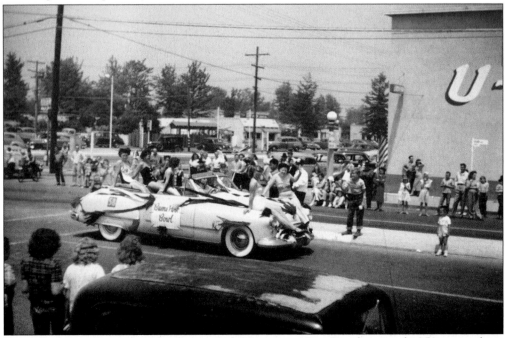

Buena Park Bowl's entry in this Buena Park Hometown Day Parade around 1950 was perhaps less about bowling than it was about showing off the bodywork on a late model convertible. (Buena Park Historical Society.)

Chartered on November 1, 1957, the Buena Park (Noon) Lions Club joined a number of other Buena Park service clubs, including Exchange, Kiwanis, Lions (Evening), Rotary, Soroptimists, Sportsmen, and Woman's Clubs. This early photo shows the Buena Park (Noon) Lions Club holding a "fathers and sons night." The club has sponsored the annual Silverado Days event since 1973. (Buena Park Historical Society.)

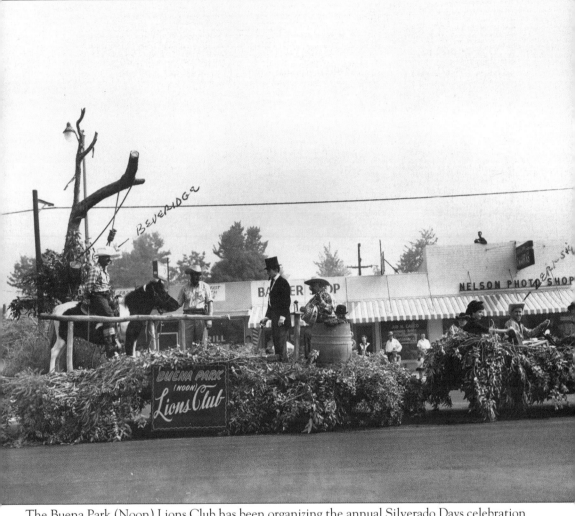

The Buena Park (Noon) Lions Club has been organizing the annual Silverado Days celebration each year since 1973 in cooperation with the City of Buena Park. Previous organizers have included the Hometown Days Committee (1957), Jaycees/Junior Chamber of Commerce (1958–1963), Buena Park Silverado Days Corporation (1964–1970), and Buena Park Chamber of Commerce (1971, 1972). (Joseph A. Klockgether.)

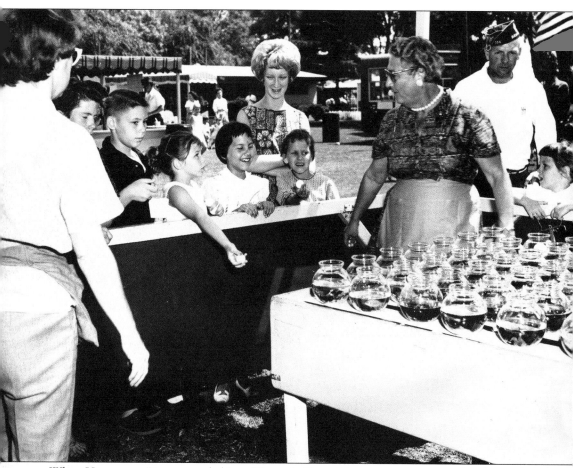

When Hometown Days expanded into Silverado Days, it became a community fair that included food, games, arts and crafts booths, and a carnival with thrill rides. In this photograph from the 1960s, children try to win a goldfish by tossing a ping-pong ball into one of the fish bowls. All booths are run by local organizations, and Silverado Days itself has no paid employees. All proceeds are donated back to community organizations. (Joseph A. Klockgether.)

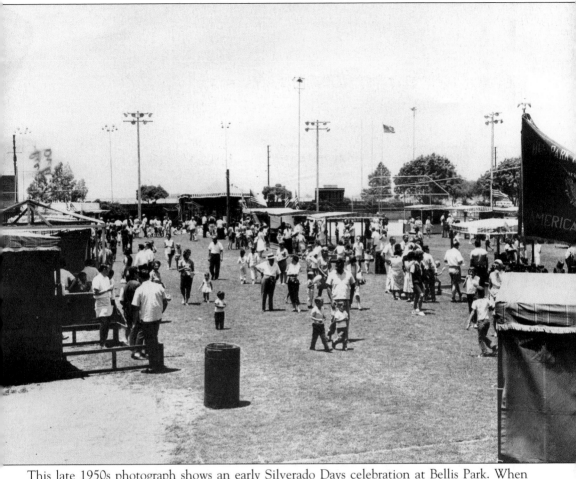

This late 1950s photograph shows an early Silverado Days celebration at Bellis Park. When constructed in 1954, the Santa Ana Freeway literally cut the heart out of downtown Buena Park. In 1956 Dick Knowles, publisher of the *Buena Park News*, visited Scottsdale, Arizona, and liked its "all-western motif." This led to a five-year master plan, known as "The Scottsdale Plan," to create a new Western-style downtown for Buena Park. Hometown Day was supposed to expand along the same lines so it needed a new name. Neal Lemons, a local businessman, came up with "Buena Park Silverado Days" although it had no significance other than sounding Western. Today, the name Buena Park Silverado Days is the last vestige of "The Scottsdale Plan" that never came to fruition. (Joseph A. Klockgether.)

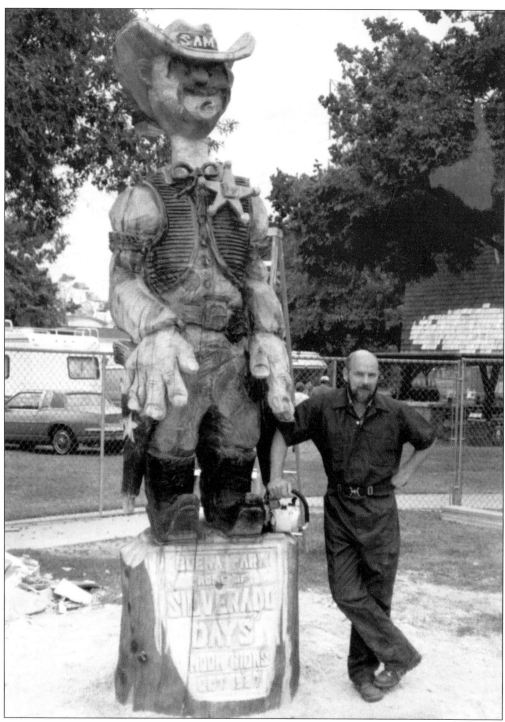

The mascot of Buena Park Silverado Days is a cartoon character called Silverado Sam, who is featured on everything from promotional literature to T-shirts to collectible pins. Here in 1987, a wood carver has captured Silverado Sam as every child expected—bigger than life. (Joseph A. Klockgether.)

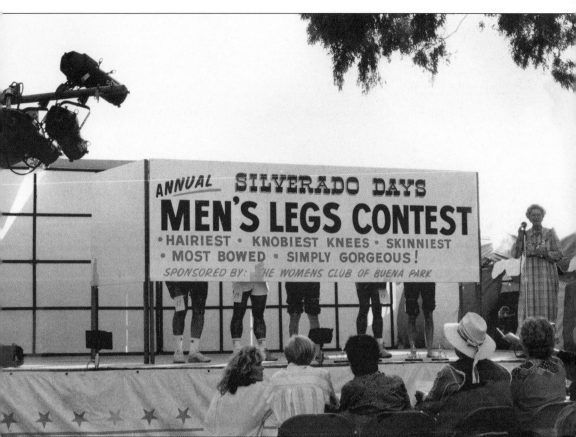

The indefatigable nonagenarian Donna Bagley officiates at a 1980s Men's Legs Contest perennially sponsored by the Buena Park Woman's Club (sign is misspelled). Mrs. Bagley has been extremely active in Buena Park for over 50 years in many organizations. From pie-eating contests to hog-calling competitions, Silverado Days retains its roots as a down-home fair with a hometown atmosphere. (Joseph A. Klockgether.)

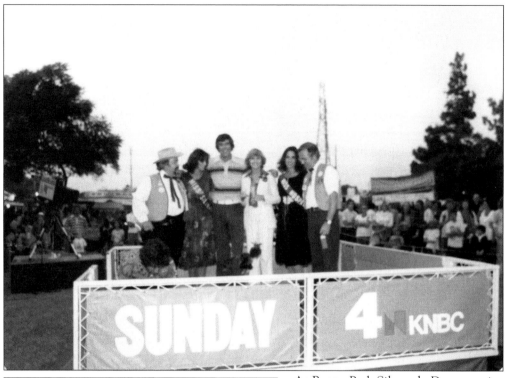

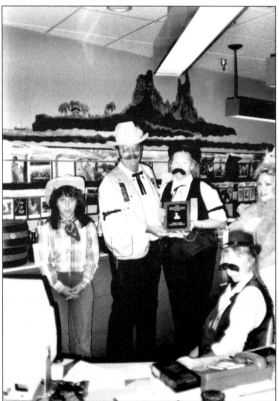

As Buena Park Silverado Days grew in popularity, it attracted hundreds of thousands of visitors each year as well as the attention of the media. Shown here in 1977, Los Angeles television station KNBC-TV 4 had live on-site coverage. On the far left is Mike Roof, who was the first person to play the role of Silverado Sam, the cartoon-character mascot of Silverado Days. (Joseph A. Klockgether.)

One of the qualities of Silverado Days is that it has always engendered grassroots participation and various off-site activities. Here in 1982, Jack Miller, a Buena Park police officer, assumed the honor of being the second person to impersonate Silverado Sam and presented the winners of the Business Dress-Up & Decorating Contest with their award. (Joseph A. Klockgether.)

The third and current Silverado Sam at Buena Park Silverado Days is Don McCay, a city councilman and retired police officer. Here, on the left, McCay as Sam awards first place in the Annual Chili Cook-Off to Rotary Club-sponsored cooks from Buena Park High School. On the far right is Grant Barnet, chairman of the board, Buena Park Chamber of Commerce, the sponsor of the event. (Buena Park Chamber of Commerce.)

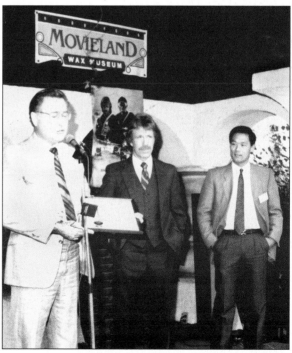

One of the benefits of having major tourist attractions in Buena Park is the opportunity to see celebrities. On this occasion, Mayor Don R. Griffin presents the key to the City of Buena Park to TV and movie star Chuck Norris in 1986. The event was part of the ceremonies unveiling his wax figure at Movieland Wax Museum currently owned by Rodney Fong, at right. (Buena Park Historical Society.)

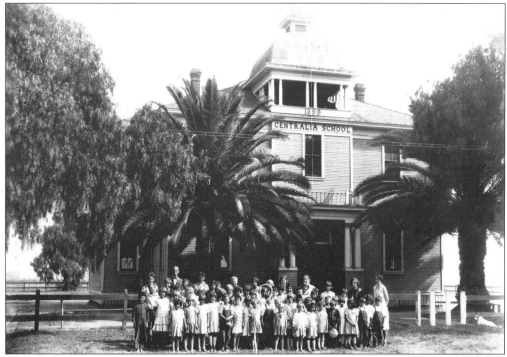

This undated photo of students at Centralia School includes a number of children who went on to become prominent citizens in Buena Park, not the least of whom can be seen circled in white. This is Marion Knott, daughter of Walter and Cordelia Knott, whose farm and berry stand was located on nearby California State Highway 39. The highway went through the center of Buena Park on Grand Avenue (now Beach Boulevard). (Buena Park Historical Society.)

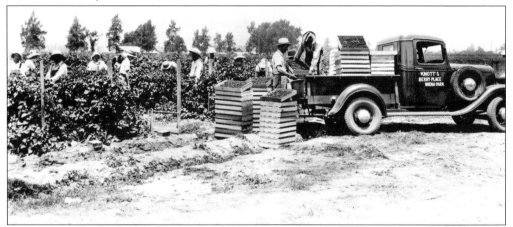

Because Walter Knott was an expert in berry cultivation, George M. Darrow of the U.S. Department of Agriculture sought him out when investigating a reported but unnamed cross between loganberry, blackberry, and raspberry. They discovered that Rudolph Boysen, superintendent of parks in nearby Anaheim, had abandoned the hybrid vines he had developed. Together they recovered the few surviving plants from a drainage ditch and Knott nurtured them into the highest-yield berry—the boysenberry—known at the time. (Buena Park Historical Society.)

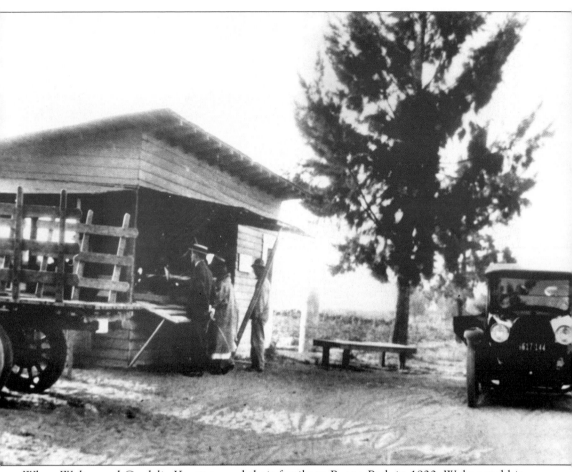

When Walter and Cordelia Knott moved their family to Buena Park in 1920, Walter and his cousin Jim Preston rented 20 acres of farmland suitable for raising a wide variety of berries. Their farm was located on California State Highway 39 so they set up a roadside stand to sell berries to people traveling this main route to the beaches. (Buena Park Historical Society.)

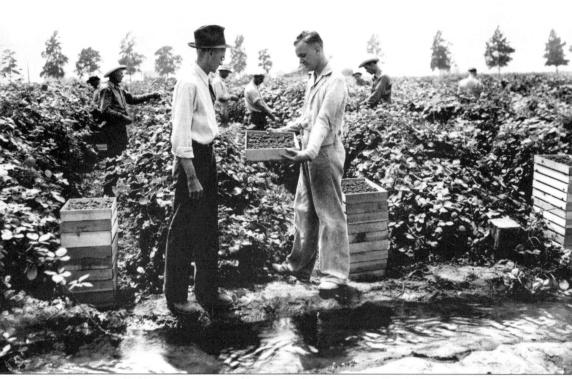

Walter Knott (left) inspects a crop of berries with his son Russell. The Knotts' farm was truly a family business as daughters Virginia, Toni, and Marion also worked hard to make it a success. In 1936 Knott began selling boysenberry rootstock to other growers so every boysenberry plant in the world can trace its roots back to Knott's Berry Farm. (Buena Park Historical Society.)

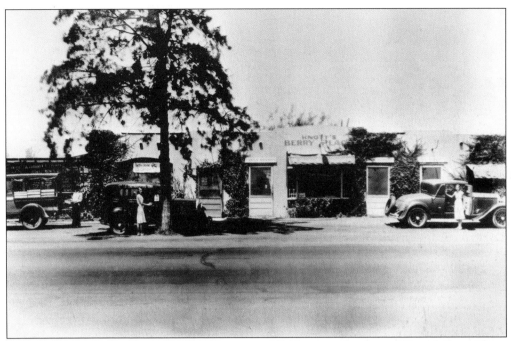

By 1928 the original roadside stand had become a full-blown market named Knott's Berry Place. A plant nursery was added when the boysenberry was sufficiently established to sell its rootstock. Although the boysenberry became wildly successful for its taste and large size, the Knotts continued to grow and sell other varieties, if at lesser profitability. (Buena Park Historical Society.)

From surplus fruit, Cordelia Knott made jams and jellies that were sold at Knott's Berry Place. When Mrs. Knott's boysenberry pies became famous, a tea room was added to serve them to visitors. In 1934, eight people sat in the Knotts' dining room and ate 65¢ fried-chicken dinners served on their wedding china. By 1937 Mrs. Knott's Chicken Dinner Restaurant, shown here, had become a major stop along the beach highway. (Buena Park Historical Society.)

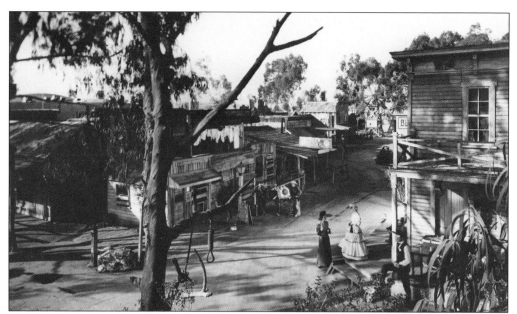

To help guests cope with long lines at Mrs. Knott's Chicken Dinner Restaurant in the 1940s, Walter Knott decided to buy, dismantle, and reassemble old buildings on his farm to make a ghost town to celebrate America's pioneer spirit and Western heritage. Many of the structures and most of the furnishings were authentic and were collected from all over California, Nevada, and Arizona. To enhance authenticity, Knott's employees wore period costumes as in this 1950s promotional photo. (Buena Park Historical Society.)

As the popularity of the Mrs. Knott's Chicken Dinner Restaurant grew so did the lines of people waiting to get in. Even after other attractions were offered as diversions to long waits, the queues became part of the mystique as shown in this 1950s photograph. (Buena Park Historical Society.)

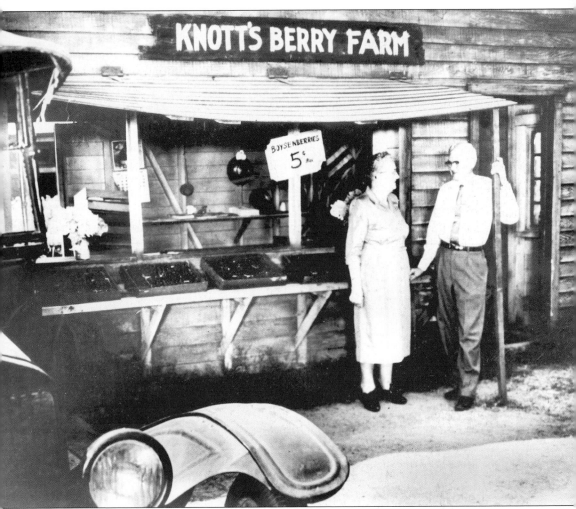

Walter and Cordelia Knott are shown here in the 1960s at a replica of the original roadside berry stand that evolved into Knott's Berry Farm & Ghost Town. Some of the original boysenberry vines were planted alongside this structure to preserve that portion of the Knott family heritage too. (Buena Park Historical Society.)

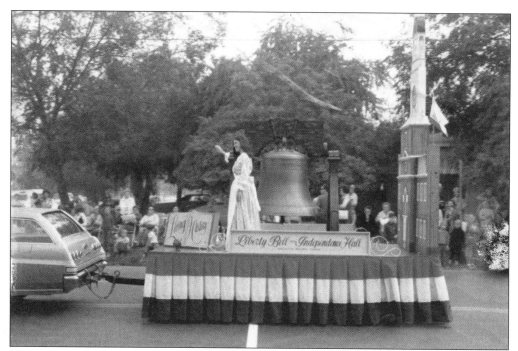

Walter Knott opened an exact replica of Independence Hall at Knott's Berry Farm in 1966. He also commissioned the casting of a replica of the Liberty Bell for his Independence Hall. Here the replica bell, weighing 2,075 pounds—only five pounds less than the original—is shown off on a float at Buena Park's Silverado Days Parade before permanent installation. (Buena Park Historical Society.)

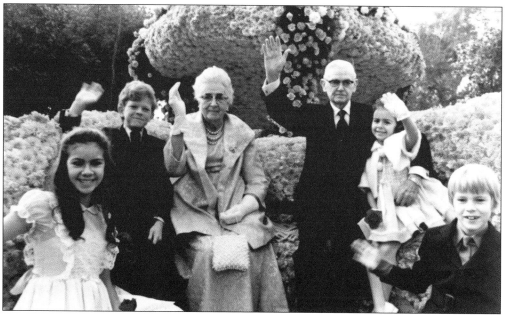

On January 1, 1971, Walter and Cordelia Knott rode with child stars of the period on the Knott's Berry Farm & Ghost Town float in the Tournament of Roses Parade in Pasadena. (Buena Park Historical Society.)

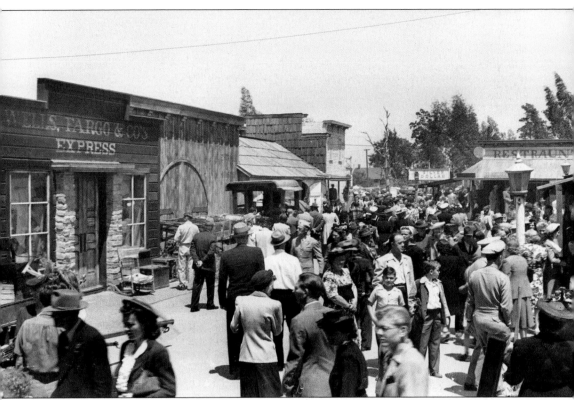

Walter Knott built the world's first theme park, Knott's Berry Farm & Ghost Town, and its success, as seen in this 1952 photo, attracted other entertainment venues to Buena Park. Today these include Knott's Soak City U.S.A, Medieval Times, Movieland Wax Museum, and Ripley's Believe It or Not. Gone but not forgotten are California Alligator Farm, Cars of The Stars & Planes of Fame, Japanese Village & Deer Park, The Kingdom of Dancing Stallions, The Palace of Living Art, and Wild Bill's Wild West Dinner Extravaganza. (Buena Park Historical Society.)

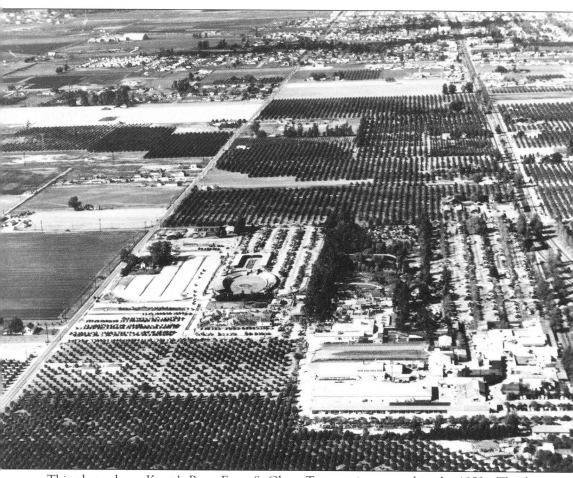

This photo shows Knott's Berry Farm & Ghost Town as it appeared in the 1950s. The farm continued producing until 1965 when berries gave way to thrill rides. Three generations of the Knott family continued to own and run operations until they sold Knott's Berry Farm food division to Conagra in 1995 and Knott's Theme Park to Cedar Fair L.P. in 1997. (Buena Park Historical Society.)

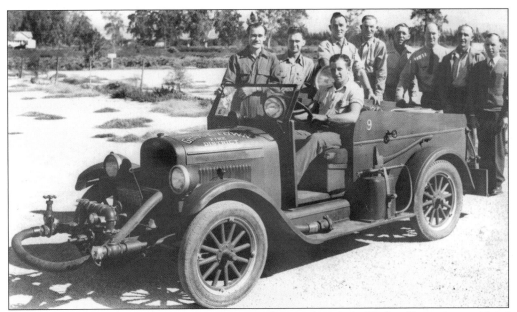

When Ghost Town was moved to Knott's Berry Place in the 1940s, Walter Knott donated land and assisted in the construction of a fire station on Grand Avenue. Initially known as the West Anaheim Volunteer Fire Department, the Orange County Division of Forestry ran the station until it was taken over by the City of Buena Park in 1955. (Sam Winner.)

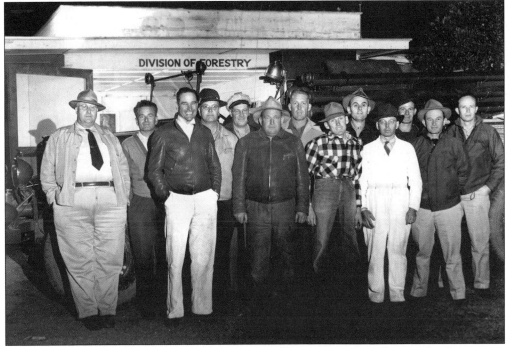

Shown here in 1947, the Orange County Division of Forestry ran the volunteer fire department at Knott's Berry Place. While the town of Buena Park was covered by another group of volunteers, this group was responsible for "all the farm areas." They were paid $2.50 per fire call plus an additional $2.50 if the emergency lasted more than six hours. (Sam Winner.)

Five

HISTORIC DISTRICT

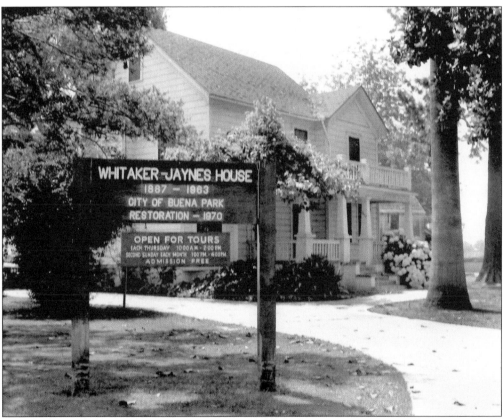

The Santa Ana Freeway encroaches on the original location of the Whitaker-Jaynes Estate Park. Shown here in 1978, the Bacon House, barely visible behind the Whitaker-Jaynes House, is being refurbished. Both houses were relocated in 1994 to make way for economic development of the prime property along the freeway. (Buena Park Historical Society.)

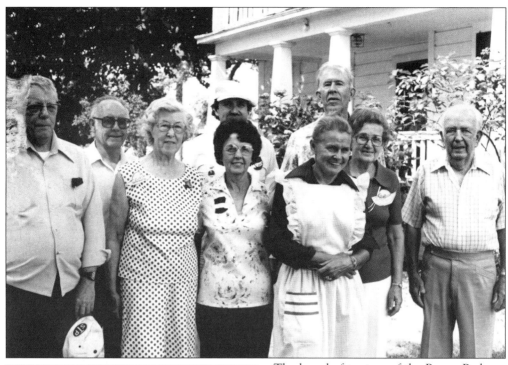

The board of trustees of the Buena Park Historical Society in the late 1970s included many pioneer family names as evidenced by this photo of, from left to right, Junior Tice, Jesse Davis, Mildred Bacon Mitchell, Doris Davis, Dean Dixon (behind), Claire Tucker, James Bacon (behind), Virgie Bacon, and Grady Travis. Grady Travis served as the first mayor of Buena Park after incorporation in 1953. (Buena Park Historical Society.)

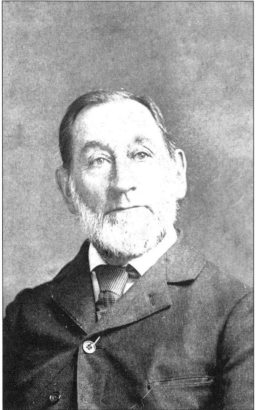

This recently discovered portrait shows Andrew W. Whitaker at age 68. Andrew was the brother of Buena Park founder James A. Whitaker. Andrew built the house that has been preserved as the home museum known as the Whitaker-Jaynes House. (Buena Park Historical Society.)

In April 1970 work was underway to refurbish the Whitaker-Jaynes House. Acquired by the City of Buena Park and established as a city park, the grounds of the old home were well known for lush gardens, rare plants, and unique roses. From a peppertree planted by Andrew Whitaker to redwood trees planted by I.D. Jaynes, the setting was historical. (Buena Park Historical Society.)

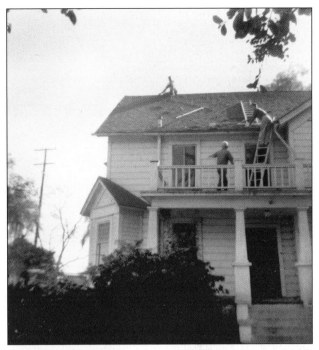

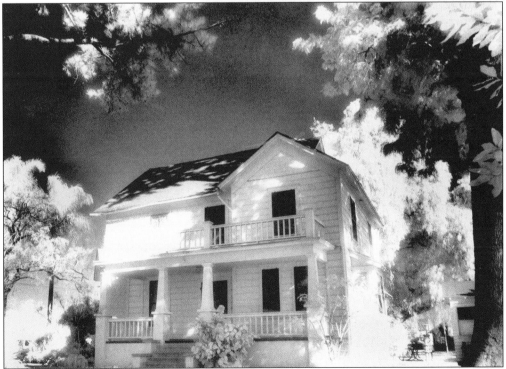

Fine art photographer Michael Morine took this photo of the Whitaker-Jaynes House in 1980 using infrared technology. The resulting ethereal image seems to convey a foreboding of the structure's move from this original park-like setting to the present high-traffic location directly across Beach Boulevard (formerly Grand Avenue) from the civic center. (Michael Morine.)

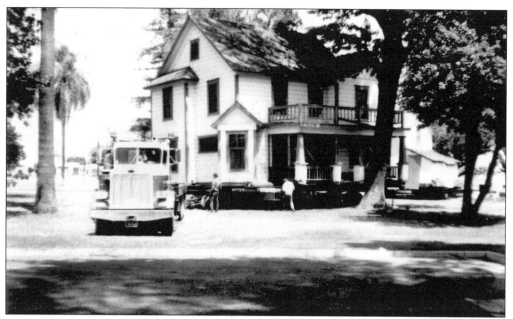

A truck hooks up to the newly mobile Whitaker-Jaynes House on June 6, 1994 in preparation for its move. Chimneys, plants, trees, and power lines all had to be temporarily removed for the route taken during the move. Boarded up in the background, the Bacon House awaits its turn to be moved for the second time in 16 years. The Bacon House is one of the few examples of single-wall construction still standing, let alone open for tours. (Buena Park Historical Society.)

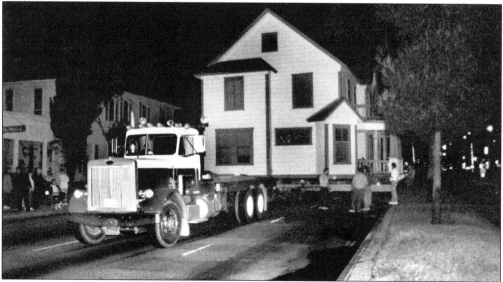

The actual physical move of the two houses took place in the middle of the night on June 9, 1994. Closing down Beach Boulevard (formerly Grand Avenue), which is also California State Highway 39, required special permits, tight scheduling, and synchronized cooperation. The California Highway Patrol and the Buena Park Police Department each had jurisdiction over portions of the move as did several utility companies who removed and reinstalled overhead lines as the processions passed. Also, the Southern Pacific Railroad had to reschedule trains. (Buena Park Historical Society.)

Pictured on their 50th wedding anniversary in 1946, I.D. and Edna Jaynes were among the most prominent people in Buena Park. Their home, the Whitaker-Jaynes House, is preserved as a museum. There they raised six children as well as a granddaughter, Barbara Jean "B.J." Ament Jennings. B.J.'s estate generously created the "Isaac DeLoit Jaynes and Edna Easterday Jaynes Fund for the Endowment of the Buena Park Historical Society." (Buena Park Historical Society.)

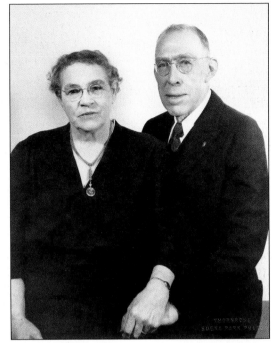

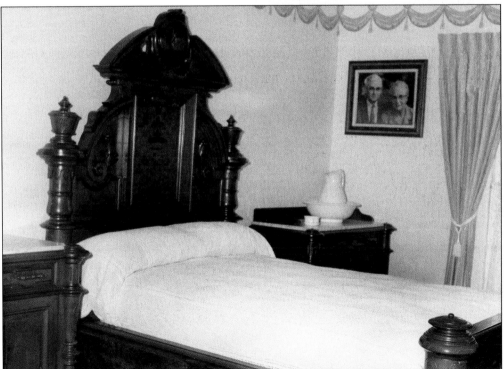

A gift from Walter and Cordelia Knott, the Knott Bedroom Suite enjoys a place of honor in the master bedroom of the Whitaker-Jaynes House and can be seen on regular tours conducted by the Buena Park Historical Society. Shown here before being moved, this portrait of Mr. and Mrs. Knott hung above the washstand on the right. (Buena Park Historical Society.)

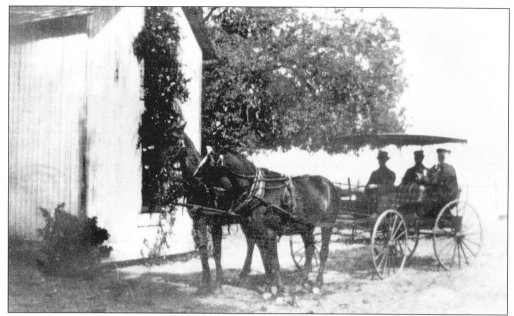

Pictured in a buggy around 1905, Robert D. Bacon, his wife, Agatha, and Jennie Dixon have stopped in front of the Bacon House. Originally built around 1884 as a squatters' shack on Rancho Los Coyotes, the house and surrounding acreage was owned chronologically by Abel Stearns, Frederick Ramige, and Jacob Hamm. Hamm sold to Bacon in 1900, which evoked swine humor among the families. (Buena Park Historical Society.)

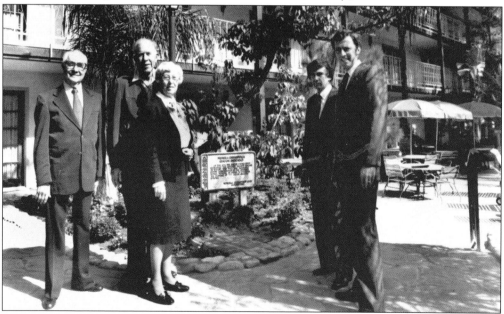

After the Bacon Farm was sold in the 1980s, hotel developers placed this plaque in their courtyard to commemorate the original location of the Bacon House as well as the first Bacon avocado and Jim avocado trees. Shown here, from left to right, are official city historian Hub Chamberlain, renowned horticulturalist James E. Bacon, historian Mildred Bacon Mitchell, and two unidentified executives of Embassy Suites. (Buena Park Historical Society.)

Because the Bacon House would not fit under any freeway overpass, the house had to be towed nearly six miles to its new location one mile "as the crow flies" from its original site. However, the relatively small size of the Bacon House did not require removal of any utility lines or closure of any streets. It moved with regular traffic flow in January 1978. (Buena Park Historical Society.)

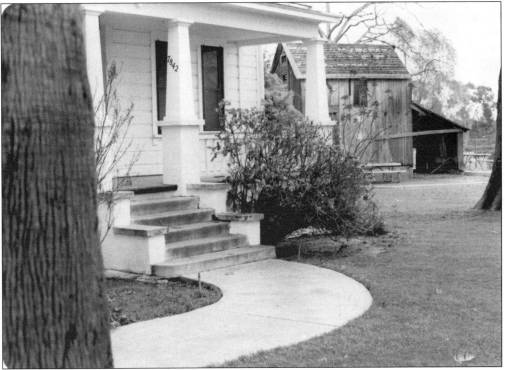

Looking through a corner of the porch on the Whitaker-Jaynes House in March 1978, the Bacon House can be seen on its new foundation awaiting a major overhaul. Used for 65 years as a storage shed, the oldest structure in Buena Park was poised to be restored as a home museum after being donated to the City of Buena Park by James and Virgie Bacon. (Buena Park Historical Society.)

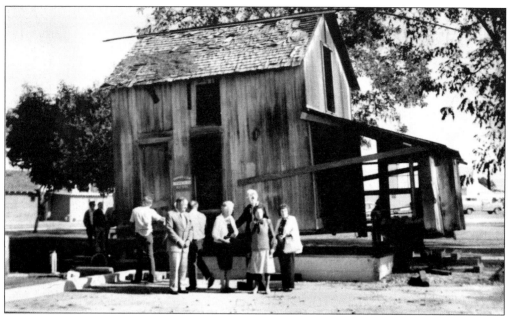

As the Bacon House was set on its new foundation at the Whitaker-Jaynes Estate Park in January 1978, onlookers included two of three octogenarians who had been born in the house when it served as the Bacon family's primary residence for a few years. Third and fourth from right, respectively, are James E. Bacon and Mildred Bacon Mitchell. (Buena Park Historical Society.)

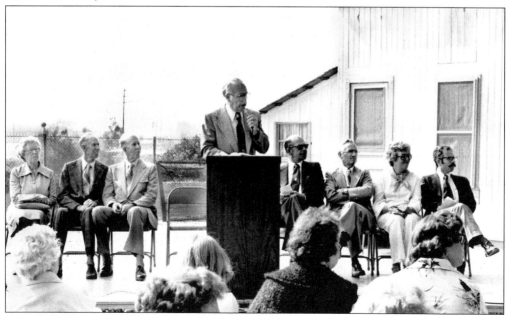

On February 12, 1979, the Bacon House was dedicated at the Whitaker-Jaynes Estate Park. Buena Park mayor Jesse Davis officiated, while sitting on the dais, from left to right, are Mildred Bacon Mitchell, Robert W. Bacon, James E. Bacon, Buena Park city councilman Stan Myers, Rev. Duane Tellinghuisen, Buena Park Historical Society president Jane Mueller, and Orange County Historical Commission chairman Don Dobmeier. (Irene Fogle.)

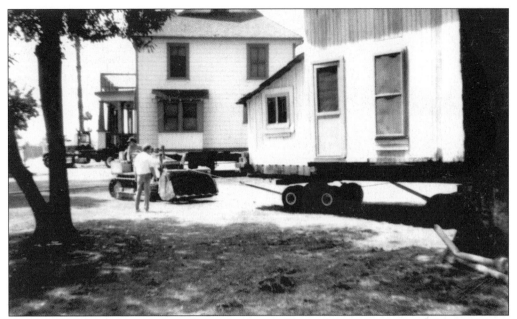

The wheels of progress are seen under the Bacon House (foreground) and Whitaker-Jaynes House (background) as both are being prepared to move from Whitaker Street and Manchester Boulevard on June 6, 1994. The new location, across Beach Boulevard (formerly Grand Avenue) from the civic center, would honor the proud tradition of both homes. (Buena Park Historical Society.)

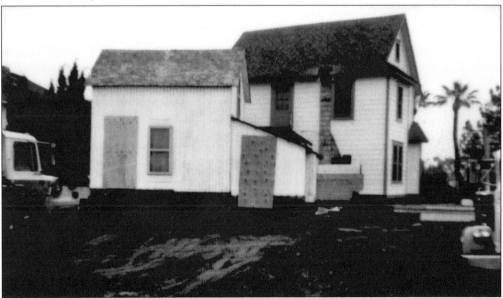

After a full night of work, the houses finally were attached to their pre-made foundations at the new location at around 6 a.m. on June 10, 1994. The Bacon House (foreground) and Whitaker-Jaynes House (behind) were photographed from what was to become the parking lot shared with the First Congregational Church of Buena Park. Months of additional work were required to make the houses presentable and safe for tours conducted by the Buena Park Historical Society. (Buena Park Historical Society.)

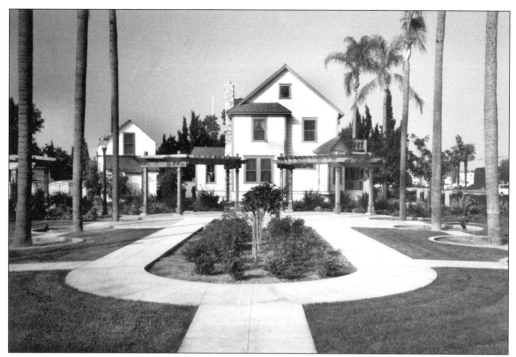

Through mutual cooperation of the City of Buena Park and the First Congregational Church of Buena Park, the church property between the church and the Whitaker-Jaynes House and Bacon House was developed into a public park fronting on Beach Boulevard (formerly Grand Avenue) across from the civic center. This was in exchange for use of city property behind the location as a shared parking lot. Moving the houses here initiated restoration of other buildings within the then–newly organized Buena Park Historic District. (Buena Park Historical Society.)

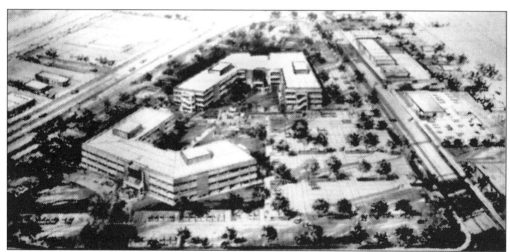

This is a rendering of a development proposed in the 1980s, which supporters called "The Super Block." The project was built to replace smaller city blocks of old Buena Park, including one where the Founder's House was located. After construction, the new buildings were under-occupied so locals dubbed them "The White Elephants." (Buena Park Historical Society.)

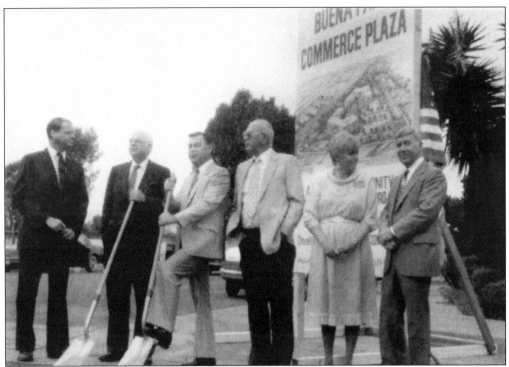

The official groundbreaking ceremony for Buena Park Commerce Plaza on September 12, 1984 included, from left to right, two unidentified executives of the development company, Mayor Don R. Griffin, Councilman Lester Reese, Assemblywoman Doris Allen, and Councilman James Jarrell. Councilmen Kenneth Jones and Jesse Davis were not in attendance. (Buena Park Historical Society.)

After the official groundbreaking ceremony, politicos and VIPs mingled with the Founder's House in the background. (Buena Park Historical Society.)

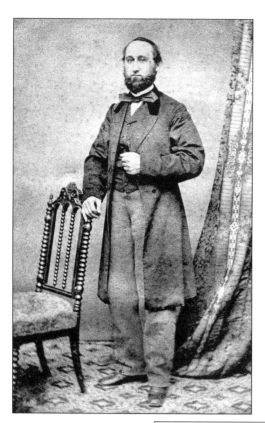

This previously unpublished photograph is of the founder of Buena Park, James A. Whitaker. The house built by Whitaker for his family became known as the Founder's House but was destroyed to make way for office buildings in 1985. (Buena Park Historical Society.)

The founder of Buena Park, James A. Whitaker, built this home for his family in 1887 after their first house burned down. The Pierce family bought the property in 1928 and turned the house away from Grand Avenue (now Beach Boulevard) to face Virginia Street. In the 1980s, redevelopment of this old section of Buena Park became the focus of political infighting. During this time the home became known as the Founder's House, shown here in 1970. (Buena Park Historical Society.)

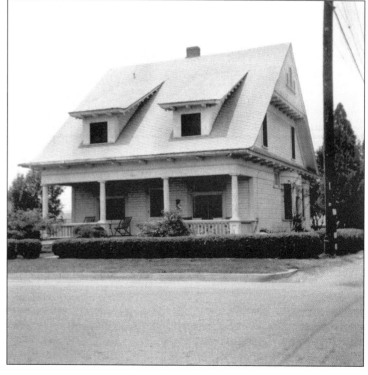

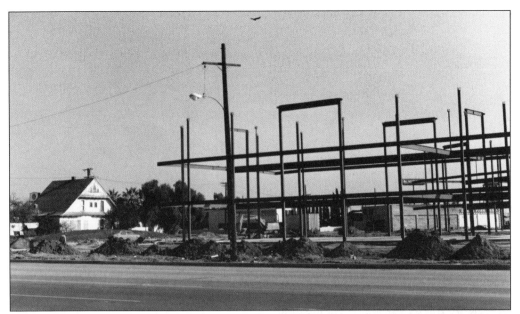

In the shadow of buildings that would cause it to be bulldozed, the Founder's House on the left literally sits in harms way as, on the right, framing construction is underway on two office buildings that would occupy the Super Block. The political atmosphere split the city council four to one with Councilman Jesse Davis casting the only vote to save and refurbish the Founder's House. (Buena Park Historical Society.)

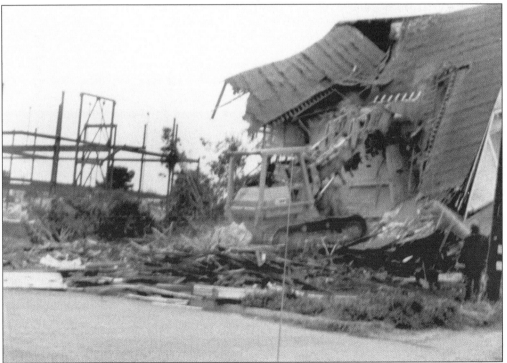

This photo from March 14, 1985 shows the Founder's House being razed on the right and the Super Block being raised on the left. (Buena Park Historical Society.)

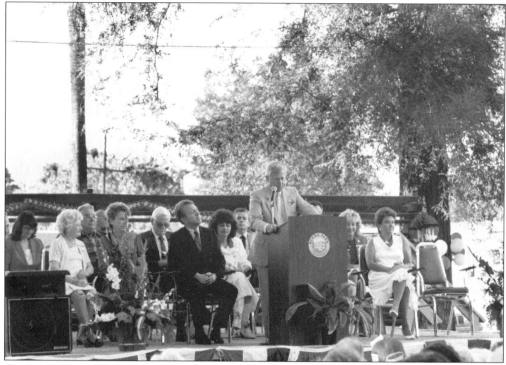

On June 17, 1987, Buena Park mayor James Jarrell opened an 18-day celebration of the 100th anniversary of the founding of Buena Park. Among the VIPs on stage were lieutenant governor of the State of California Leo T. McCarthy (left of podium) and Madeline Whitaker Fowler, granddaughter of Buena Park's founder, James A. Whitaker (second from far left). (Irene Fogle.)

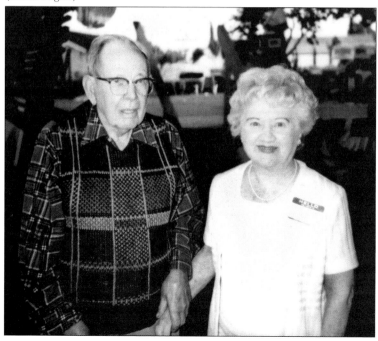

At the opening ceremonies of the Buena Park Centennial in 1987, old friends John Mitchell and Madeline Whitaker Fowler get reacquainted. During the previous century, they and their families contributed greatly to Buena Park. The Mitchell Brothers' Garage is featured in this book as is Mrs. Fowler's grandfather, James A. Whitaker, founder of Buena Park. (Buena Park Historical Society.)

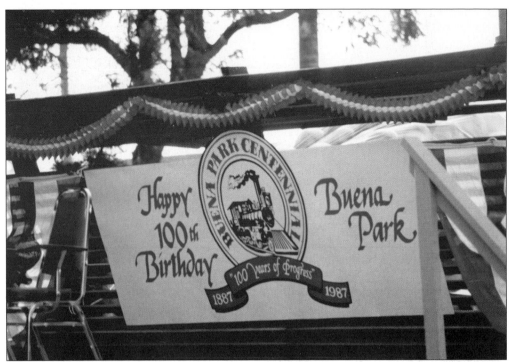

As shown here at the opening ceremonies of the Buena Park Centennial, the event's logo had been redesigned. The first version depicted a covered wagon, which was inappropriate for a community that only came into being because the railroad had come to town. A wide variety of events over an 18-day period culminated in a fireworks show on the Fourth of July at Bellis Park. (Irene Fogle.)

Taken around 1893 in Los Angeles, this is a childhood portrait of Madeline Whitaker, granddaughter of James A. Whitaker, founder of Buena Park. She enjoyed a sprightly life well into her 90s and was an honored participant in various events of the Buena Park Centennial celebration in the summer of 1987 as well as Silverado Days the same year. (Buena Park Historical Society.)

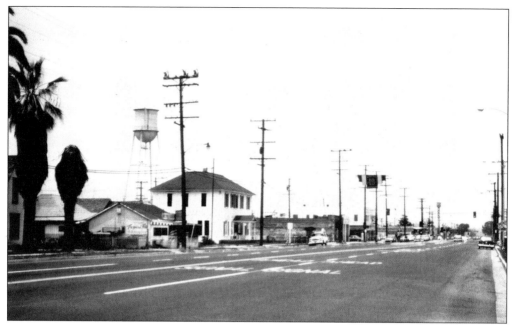

Taken from the civic center in 1963, this photo of the Stage-Stop Hotel (just left of center) also shows the water tower in the background. Above the street is a small banner printed "Buena Park 10th Anniversary" to celebrate ten years of incorporation. (Buena Park Historical Society.)

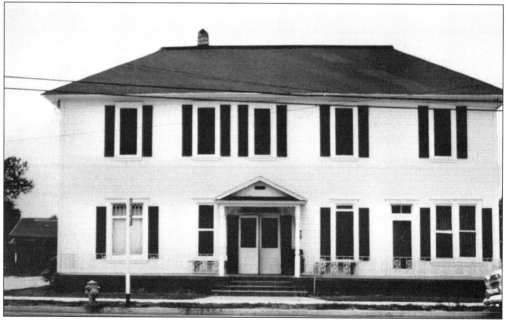

Again in 1963, the Stage-Stop Hotel is pictured before flat-roofed additions of an antique shop on the left and a portico on the right side. The structure reportedly had a checkered past including use as a hotel, boarding house, bordello, flophouse, and private residence. Today the Buena Park Chamber of Commerce occupies the restored ground floor and the Convention & Visitors Office is upstairs. (Buena Park Historical Society.)

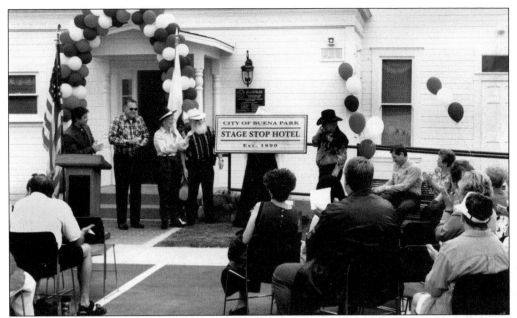

On June 17, 2000 the completely refurbished Stage-Stop Hotel was dedicated for use as the offices of the Buena Park Chamber of Commerce and the Buena Park Convention & Visitors Office. Shown standing at the podium, from left to right, are Mayor Steve Berry, Councilpersons Gerald Sigler, Patsy Marshall, Art Brown, and Jack Mauller. (Gail S. Dixon.)

The Stage-Stop Hotel was built in 1870 as overnight accommodations following the first day of travel from Los Angeles by stagecoach. Similarly, it was the last overnight stay for travelers before their final day's trip into Los Angeles. Refurbished by the City of Buena Park in 2000, the building is part of the Buena Park Historic District. (Gail S. Dixon.)

For decades, H.A. "Hub" Chamberlain was called the "unofficial historian" of Buena Park. He began researching and writing as part of his job with the Southern Pacific Railroad and continued with his avocation while working for the City of Buena Park as superintendent of building. His series of 125 articles titled "From Coyotes To Commerce," published in the *Buena Park News* from 1972 until 1974, are the most comprehensive writing on the subject. A city council proclamation ultimately recognized Chamberlain as official historian of Buena Park. (Buena Park Historical Society.)

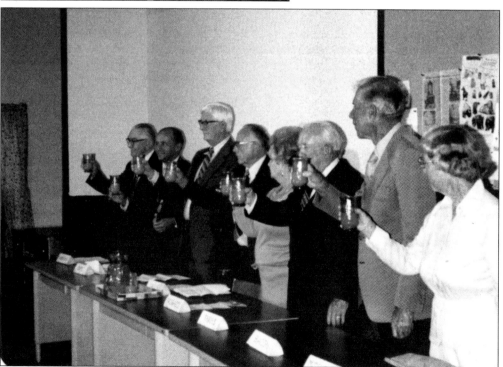

On June 26, 1979, Buena Park Historical Society president Claire Tucker convened a panel of "old-timers" to discuss local history for a film crew. Seen here toasting the event from the dais are, from left to right, Hub Chamberlain, Anthony Fonte, Kenneth Jones, Jesse Davis, Elva Leisch Hughes, Grady Travis, James Bacon, and Mildred Mitchell. The event was held in the old water-district building on Ninth Street. (Irene Fogle.)